YOU ARE AN ARTIST

BOB
AND
ROBERTA SMITH

YOU ARE AN ARTIST

WITH 130 ILLUSTRATIONS

CONTENTS

I WANT EVERYONE
TO GO TO ART SCHOOL
BUT THE WHOLE
WORLD IS ART AN SCHOOL

INTRO-
DUCTION

LEARNING

Whether you like it or not, you have been enrolled in the world and it is an art school. *You Are an Artist* because every human being who has ever lived was once an artist. All children are artists. Drawing images is an important part of how we learn. Parents know that teaching their children how to read, write and talk is, above all else, a conversation. Talking to a child elicits a response.

Most children's first words are variations on 'Mum' or 'Dad'. A friend of mine who was born in 1963 professed that the first words she ever uttered were 'yeah, yeah, yeah', because she had been aurally exposed to The Beatles singing 'yeah, yeah, yeah' in the chorus of the hit song *She Loves You*.

VISUALITY

Visuality plays an important part in learning to talk. Early childhood drawings might be circles or squares or a forest of lines. My wife, the artist Jessica Voorsanger, and I kept what we could of our children's early drawings. I remember asking my daughter Etta, who had made a drawing, 'Is that Mum or the cat?' She said, 'No, this is a giraffe.' The drawing did not look much like a giraffe, but she was proffering the idea that the marks she had made related to her love of giraffes (Etta is now, twenty-two years later, a successful graphic designer). Etta's giraffe was in a house. The house was represented by a square. I can remember the conversation: 'What does the giraffe eat?' 'Has the giraffe got a mummy and daddy?' 'Does the giraffe wear a dress?' Etta made drawings of all these elements. She then announced that the giraffe had a car, and a circle appeared as she made a *vroom vroom* sound, imitating the petrolhead giraffe speeding off into the sunset.

JOINT ATTENTION

We had many conversations with Etta through drawing. All parents do. Early-years teachers know the routine: the child is the celebrity and the teacher the interviewer. These conversations are made possible through the human capacity that psychologists have identified as

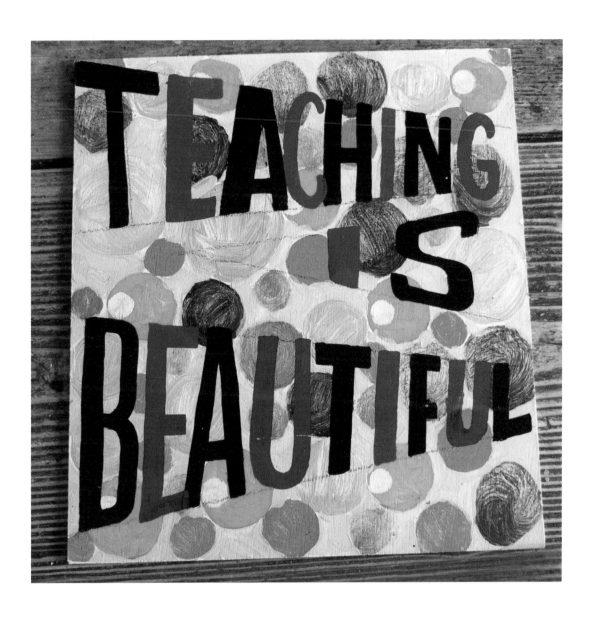

You Are an Artist

'joint attention'. We are able to draw attention to an object or a concept in order to involve another person (we share this capacity with dogs and chimpanzees). All language is facilitated at root by joint attention, enabling us to have conversations about any number of subjects. These subjects, be they objects, concepts or processes, are the raft upon which human interaction is built. Importantly, we are able to ask our friends, **How about this...?** Children are constantly asking, **How about this...?**

DIALOGUE

The question **How about this...?** is fundamental to art and design because artists and designers are saying it every time they pick up a paintbrush or pencil, or turn on a video camera.

In the twenty-first century we finally have a kind of 'dialogical' art. A revolution in art and design has recognized that the voice of the audience contributes to and formulates our art in a much more conversational way than had previously been thought. **How about this...?** say the artists, and **How about this...?** say their audiences. Art is now part of a huge societal feedback loop. This book aims to include you in a dialogue that will strengthen your voice.

We think of children as uninhibited. Play and the free exercise of the imagination are essentially the same thing. A piece of wood can be a car; a pile of stones is a *corps de ballet*, or an army. Imagining that a piece of wood is a car is saying, **How about this...?** This process is all about language. It is a dialogue between human beings. Such dialogue is about images and objects as much as it is about the kind of written language that is formally taught in schools. Indeed, this aspect of communication should be fostered in schools as well. As I have proclaimed in paint many times, *All Schools Should Be Art Schools*.

GENEROSITY

As a child's education progresses, bodies of knowledge need to be accumulated, and so at some point the dialogue between teacher and child becomes more one-sided. The child abruptly ceases to be the interesting

celebrity and is seen by educational authorities as a 'sponge', or a bucket, to be filled to the brim with facts. *BUT*, in the art room, on the stage, while writing a poem, and while holding a musical instrument, the **How about this…?** question still lingers in schools. We should want our kids not to be audiences for teachers, but rather learners in a dialogue with folks from the previous generation, who are able to introduce the rich menu of the world to its new participants. We should demand a generous dialogue.

Maths teachers require that children show their 'workings out'. But mathematics, like art, requires imaginative leaps. It is a major educational failing that the links between mathematics and the arts – pattern, the imagination, complexity – are not taught in early-years education, in a subject that should be called 'Leonardo da Vinci 101'.

CHUTZPAH

We need more people to feel empowered to say **How about this…?** We think of artists, architects, writers, musicians and actors as brave because they break through the walls of inhibition and have the self-belief and chutzpah to ask, **How about this…?** But we can all be brave. This book is for everyone. Be brave. Grab hold of a pencil and draw. You once were an artist. You were quite a conceptual artist and an abstract artist with an interest in language, but you also used to like making marks for their own sake.

This book takes you through ten aspects of the arts, and asks you to respond to a number of provocations. These are based on exercises I have used with students in over thirty years of teaching in art schools and universities.

CURIOSITY

Apart from being dialogical, art is shaped by curiosity. I believe that the kind of curiosity that leads to art is guided by shifting, polyphonic algorithms. Computers use algorithms to sort and sift information about the world. Throughout this book runs the idea that curiosity is – in some magical-seeming way – a neurochemical device, similar

HOW ABOUT THIS?

'BE BRAVE.

GRAB HOLD

OF A PENCIL

AND DRAW'

to an algorithm. I hope to show how curiosity can be switched on through art-making.

I mentioned my thoughts on the connections between algorithms and curiosity to a mathematician friend of mine. He said one distinction would be that algorithms are not instructions to create something new, but rather they are a strategy for going through a set of data and pulling out the information that is needed. The results may appear creative, but they are not the computer's invention. The application of an algorithm to a problem is, in such a case, less a generative process than a form of looking. In art-making, however, both the algorithm *and* the process are creative. Perhaps human innovation lies in the artist's desire to link the results of looking to the concept of asking, **How about this...?**

SYNAESTHESIA

As I write this, I am sitting on a train to Ramsgate where my studio is located. I look up from writing to think, to stare into the void, and I see the landscape shifting. My eye is picking up information. Poplar trees rhythmically flutter past. In the middle distance is a tree line. Every now and again there is a lake. In what seems a different time signature, there are red brick bridges. There is a flickering fence alongside the railway. I have thought many times that the occurrence of these phenomena could form the basis of musical notation.

How about this...? Maybe I should contact Network Rail and ask them to fund an orchestra to travel to my studio and play what they see out of the window. Violins could play the fence posts, imagining them as fence-post crotchets. Cellos could play a sweeping melodic line, mirroring the trees in the middle distance. Kettledrums could sound the languid occurrence of lakes. Trombones could blare at the sight of each bridge. The orchestra could substitute a musical score for an Ordnance Survey map. The map would become a set of synaesthetic instructions. But instead of seeing sounds as colour, as in synaesthesia, the orchestra would see landscape as sound.

Of course, this kind of work already exists. Think of Vaughan Williams, Beethoven and Dvořák. These composers all wrote pastoral

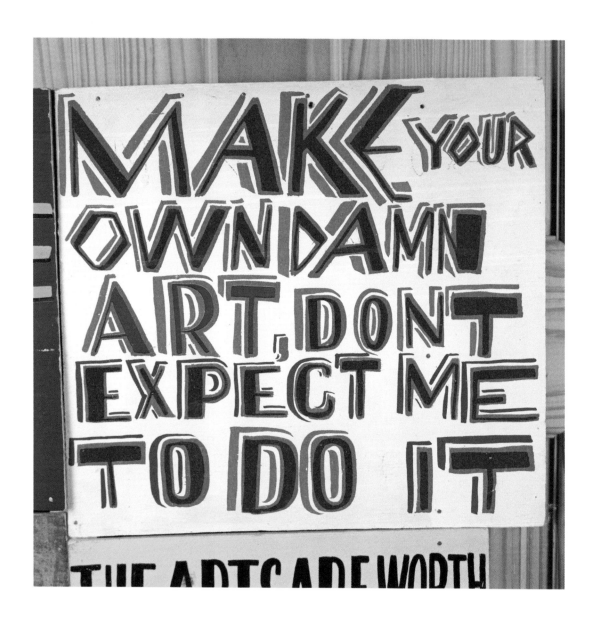

You Are an Artist

symphonies in which music worked in various ways to resemble nature. The resemblances are discernible to all in part thanks to the development over time of a musical 'language', itself formed via joint attention and feedback loops. Similarly, the peacefulness of a lake might be captured in visual art by various means. The principle remains the same. There is a template for converting a scene, and it is a kind of recipe, applicable in different ways to different subjects. We can see this as artistic, but also as algorithmic, metaphorical and mathematical.

One of my best-known slogans, and the title I have given to one of my books, a film and several performances, is *MAKE YOUR OWN DAMN ART*. I believe art belongs to everyone, and we should all be challenged to exercise our creativity. Within this book you will therefore find a set of suggestions – poetic algorithms, recipes, or, as the French would refer to them, *dérives* – to guide and inspire you in this challenge. In each case, I ask you: **How about this...?** I hope you will apply these algorithms in different ways to MAKE YOUR OWN DAMN ART.

TIME, BEGINNINGS AND INSPIRATION

STRUCTURE

You need art, but art also needs you! Art needs all our voices in order to reflect and contribute to the world we live in. In art schools, teachers (ourselves practising artists) like to provoke students, make observations, offer suggestions and pose questions. We give instructions and set work based on what the student has achieved. After completing work in the studio, we ask our students to make an evaluation. Based on that reflection we ask, 'What are you going to make next?'

The structure is simple, but it's a proven method of engaging students in discussion about artworks, and one that has endured in art schools since the 1960s. This kind of staged conversation might feel uncomfortable to a few, but it's useful if you (the student) are to question and develop your voice in the context of your experience and the world we share; if what we are aiming for is not simply me transferring what I know to you. It is student-centred learning – *learn yourself cleverer*! THIS IS A PRINCIPLE USED IN ALL ART SCHOOLS. It's 'aleatory' learning – as in, it involves an element of chance. Art schools ask students to put novel ideas together, like rolling dice, and see what results. Art teaching is always about chance. Working in this way, I can help most people who want to make art.

Some parts of this book will seem more relevant to some readers than to others; it's perfectly OK to engage only in parts you like. There are a number of projects that involve doing unmentionable things to innocent objects. If this book needs casting in concrete, go right ahead.

INSPIRATION

It makes sense to start by thinking about inspiration. Where do ideas originate? Early morning is associated with inspiration. Brain scientists now think that because the brain processes the questions of the previous day overnight, it's early in the morning upon waking that solutions occur and appear to us as inspired ideas. Most people instantly forget what their brains are telling them. Most early morning moments of revelation are smothered by us pressing our own in-built 'snooze button' and falling back to sleep.

MAKE A LOOP DRAWING

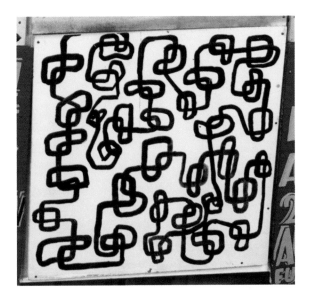

I caught my four-year-old son making a drawing. I said, 'What's that?' He said, 'It's a loop drawing, Dad. I draw a loop, then I run a line through the loop, and I do it until I've filled the page.' I said, 'That's amazing. You have created an algorithm, a recipe, an instruction.'

Follow my son's rule, and make your own loop drawing. Understanding the process here will illuminate the approach of this book. The template created by one artist can be adapted by another with very different results. This is something that becomes more and more apparent through practice, and I am asking you to learn about art through practising art in a broad variety of ways.

Making art is not an academic subject. You can learn about art by studying it, but only by making it can you learn to be an artist.

How about this...?

DRAW FIVE INSPIRATIONAL OBJECTS

1. I love coffee. It's a great stimulant and generally harmless. Stay off the hard stuff.

2. Pasta shapes have come about via the ecology of a food culture that perfectly evolved to complement the different sauces of the Italian kitchen. Pasta is Italian folk art.

3. Attempting to work with new art materials forces us to see the world in new ways. Try asking your family to give you art materials as presents.

4. I'm enthralled by railway engineering, and the life-changing opportunities that trains create; the exciting idea of networks connecting us; the glamorous liveries of the twentieth century; the sheer romance.

5. This is a painting by my father, Frederick Brill. At Ribblehead Viaduct, during the industrial age, railway engineers created Britain's greatest land artwork.

What do you find inspiring? Have fun engaging with objects or experiences in a purely visual way.

How can we capture moments of revelation? One way would be to acknowledge and voice what you are thinking to a partner or a friend, or even just to yourself. It might seem teenager-ish and pretentious to write down parts of dreams or speculative ideas, but it's important – not because what we are engaging in is in any way psychoanalytic, but just because we have a huge propensity to forget ideas.

Get a pencil and a sketchbook or notebook. Arm yourself for forgetfulness. Write your own programme of inspiration. What turns you on? When do you feel inspired?

COMMUNICATION

We can all be quite conservative. Art is a part of a feedback loop that can demonstrate to us just how narrow our thinking can be. This is often sobering. When I was a student, my art school travelled to Russia. We were shown around Moscow by a group of art students. At the end of our trip we were asked to make a gift for them, which would be exchanged at a party. Two of us made a time-consuming poster of Lenin, including lots of images of things we had seen, like the swimming pool that was built in the ruins of the cathedral that was blown up by Stalin, and the shocking mass graves that we had seen in St Petersburg. The party wasn't great. We didn't understand the cutesy Russian paper doll they gave us, and they looked crestfallen with our poster full of images that we liked or were impressed by, but that they hated.

We had misunderstood the exchange. We lacked the insight into Russian culture required to see that presenting our hosts with images of the brutal seamarks of Soviet society would offend them. The art we had produced was born of an internal feedback loop that we understood, but in which we did not include our audience. The art we made was just for us. We should have done some genuine research into all things Russian, rather than revel in the madness of their propaganda machine. We should have opened up the feedback loop to include our hosts.

That trip to Russia changed my life. I became aware of stencils for the first time. All the machinery and road signs were hand-painted or stencilled with spray paint. Propaganda, which I had only seen directed

against Hitler, took on a different air when it was directed against business or entrepreneurial activity. We all discovered that Russian Abstraction, Suprematism and Constructivism had their roots in the formality of the icons made by the great fourteenth-century artist Andrei Rublev. Subsequent trips to China, India, Italy, Japan and America have informed everything I make, because I have encountered not simply different aesthetics, but different ways in which human beings have tackled universal problems.

JUXTAPOSITION

The confrontation between two opposed or unrelated concepts can set off inspiration. Juxtaposition is often satirized as an 'art school' idea, but it is nevertheless a great tool. The Dadaists and Surrealists were keen exponents. Salvador Dalí's 'dream images' are often nothing of the sort. There is method to his imagination, and that method is revealed in his 'Exquisite Corpses', or, as we name them rather prosaically in Britain, 'Heads, Bodies and Legs'. The more literary version of the game, 'Consequences', reveals how the Surrealist filmmaker Luis Buñuel (Dalí's onetime friend) came up with the plots for *L'Age d'Or* and *Le Chien Andalou*.

In Consequences, all participants have a piece of paper. First, everyone writes the name of a woman (hidden from the other players), followed by the word 'met'. The name is folded over, and the paper is passed to the person on the left, who adds a man's name, followed by the word 'at', folds, and passes it on. The name of a location is added (fold, pass it on), then 'She said' (fold, pass it on), then 'He said' (fold, pass it on). Finally, someone adds the 'consequence' ('and the consequence was...'), folds and passes it on to have the whole unfolded. Here is the result of a game of Consequences I recently played with my son Fergal:

How about this...?

FIND FIVE OBJECTS THAT MAKE A NOISE AND FORM A BAND

DONT JOIN THE APATHY BAND

Your musical objects can be as outré as you wish: a coffee grinder, a whisk, marbles in a bowl, a broom sweeping the floor, nails to be hammered into wood... I enjoy playing with my balloon orchestra.

How about this...?

MAKE AN ARTWORK THAT IS REFLECTIVE OF TIME, A MOMENT OR A NEWS STORY

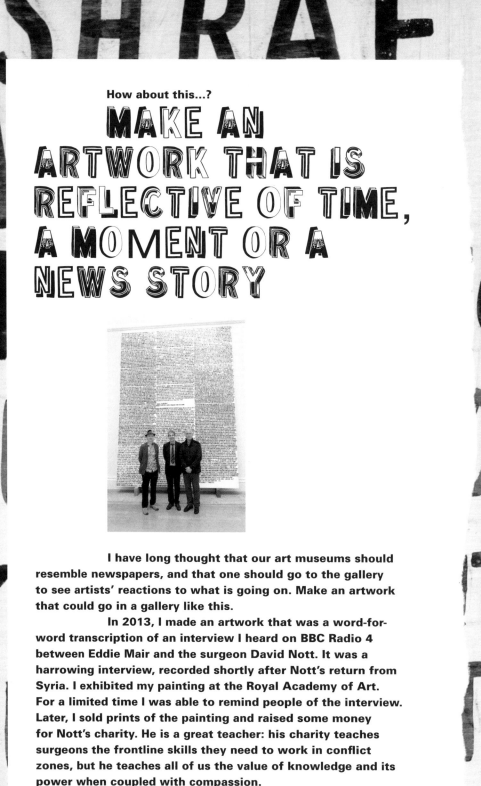

I have long thought that our art museums should resemble newspapers, and that one should go to the gallery to see artists' reactions to what is going on. Make an artwork that could go in a gallery like this.

In 2013, I made an artwork that was a word-for-word transcription of an interview I heard on BBC Radio 4 between Eddie Mair and the surgeon David Nott. It was a harrowing interview, recorded shortly after Nott's return from Syria. I exhibited my painting at the Royal Academy of Art. For a limited time I was able to remind people of the interview. Later, I sold prints of the painting and raised some money for Nott's charity. He is a great teacher: his charity teaches surgeons the frontline skills they need to work in conflict zones, but he teaches all of us the value of knowledge and its power when coupled with compassion.

Theresa May
met
Nelson Mandela
at
Aldi supermarket
She said, 'I really fancy you big boy.'
He said, 'I cannot agree to your backstop.'
She got all dolled up and put on her lippy. He capitulated, succumb-
ing to her demands, filling her basket with ripe red peppers and
a cauliflower. And the consequence was... Turmoil!

TRUTH

As I write this, the world is in turmoil. Even before we were overtaken by a global pandemic, Donald Trump's presidency had turned upside down many expectations about how governments should behave. We are confronted with new means of digital communication in which we can no longer be confident. We know that images and information may be subject to the malign aims of politicians and corporations. Trump acts like a Young British Artist. It is as if he has adopted Damien Hirst's pickled shark shock tactics (in Trump's case, a wall) and his butterfly-hatching charm (in his support for North Korean leader, Kim Jong-un). Trump creates waves with culture, just as Dalí once did. Trump and Hirst think this approach still works.

In the twentieth century, we got used to a world in flux: modern life was fast-paced, and art was constantly evolving. In the twenty-first century, politicians like Trump are asking us to conflate technological change with truth. They say that truth is changing. 'Experts are fools!' they cry. Evidence is undermined and nothing, it seems, is 'real'. These ideas are part of the reason why the arts are so important.

The poet John Keats explored art's relationship to truth in his poem 'Ode on a Grecian Urn' (1819). The urn is enduring and transcendent, and so it is good and beautiful and true. Art is a kind of ultimate test of the value of truth. At the very least, human beings thrive when their inventions are both truthful and beautiful.

The quest for scientific truths in the eighteenth-century age of Enlightenment led eventually to new kinds of beauty such as Prince Albert's Crystal Palace, which opened in London in 1851, or Isambard Kingdom Brunel's 1864 Clifton Suspension Bridge in Bristol. These more systematized forms of beauty in architecture (and art) included ideas of morality and purpose. Artists have become truth seekers. Lots of artists means lots of investigators hunting after the truth – lots of people looking. That's why Trump tried to close down the National Endowment for the Arts, and why the British government sought to limit children's access to the arts. Less art = fewer irritating truth seekers.

RELEVANCE

Despite our sense that the truth is still 'out there somewhere', we feel that everything is in flux. How can we make something that feels relevant amidst this sense of constant change? Paradoxically, I ask you to turn on the television for inspiration.

I used to show with a gallery in Turin. Art in Turin was dominated by two art movements: Transavanguardia (mostly painters) and Arte Povera (mainly sculptors). The gallery I showed with did not represent either of those groups. My dealer was called Guido Carbone. Guido had made his money from setting up and then selling the first American-style ice cream shop in Turin. It was called 'Pop Gelato'. Ever one for the main chance, Guido persuaded artists at his gallery to make paintings based on images from television. He felt that neither Transavanguardia painting nor Arte Povera expressed the concerns of 'real' people. Guido was into all things Pop, including ice cream, and he wanted to create an Italian Pop Art movement that would connect with everyone and reflect the divisions of everyday life. He christened his artists 'Gli Televisioni'. Few people now remember Gli Televisioni, which is a shame because many of the painters were really good and made interesting art.

Whatever your inspiration or starting point, remember there are no blank canvases. We all have something to say.

MAKE A PAINTING THAT IS SUBJECT TO EVENTS

Make an artwork that will be affected by time or the weather. This type of painting is made to go outside. Mine only come inside when they are shown in galleries. Otherwise I keep them wrapped in plastic in my garden in London. They are deteriorating. They are subject to damp and time.

How about this...?

DEVISE A MUSICAL NOTATION

Create a musical notation for your band to play, and draw it out. You will have to create a timeline and a system of prompts so that your fellow members know when to come in. Will the band follow the notation in a rigid way, or will there be an element left to interpretation?

Record your efforts on your mobile phone. Then put the musical notation to one side and make a work that is inspired by the music you have created. In doing this, you will make an expressive image (one of mine is above). Your painting or drawing will mark an event, and you will use marks on a page to express the feeling of the sounds you produced.

After you have finished, compare the two artworks. The musical notation is 'pre-hoc' (before the event). The impressionistic painting of sound is 'post-hoc' (after the event). The music itself is the event. This exercise is a microcosm of the creative process.

TIME

Where are we in time? What does time mean for us? Importantly, what has time done for you or to you? We should think about objects as repositories of time. If you cut through a piece of wood with a saw, you reveal rings of time. Almost everything around us has 'faded from sunlight' or 'sagged under its own weight', 'collected dust', 'fallen apart' or 'sprung to life' over time.

Time is cruel – unending if you are young and too fleeting if you are old. Gallery-goers spend on average seven seconds in front of a painting, while to make a painting might have taken the artist months or years. Writers demand that we spend days reading their books, filmmakers sit us in a dark space for hours, but artists who show in galleries are subject to 'fleeting glances' – from people with 'uncomfortable shoes' and demands to visit the café and the gift shop. Time is an ineffable subject for art. Time is impossible to convey, and that's why it's a great subject for artists.

Over time, objects are subject to erosion and decay. Human relationships change over time. If you are a parent you know that your children start by adoring you, then being bored by you, then leaving you, then being pleased to see you every now and again. All this time you adore them.

All musical notation is a visual record of time. Instructions compel the reader to spend time obeying or following them. We are composers who wrestle with time. Think about the world around you not as the result of events but as a set of questions and provocations.

Music is inspirational. I like to listen to recordings of improvised music in my studio. I listen to jazz but also to classical and electronic music. What happens when I am working is that I am not listening. The music falls away, and I am gripped in a silent conversation with my own ideas.

SPACE

Virginia Woolf argued that, in order to create, a woman needs 'a room of her own'. A room of one's own is time to think, permission to explore,

opportunity to gain confidence to speak up. To begin making art you are going to need some materials and a space.

But art need not be completely solitary. Music is often an ensemble activity, and performance and theatre productions involve collaboration. The process of writing music, devising plays and developing ideas demands attention and time, which includes time to be alone (for part of the day, at least) though not necessarily isolated.

TRAVEL

Art need not be made in just one room. *Go somewhere and tell us about it*. This might, in fact, be a recipe for writing a book. For visual art, it works in many ways. J. M. W. Turner's sketchbooks reveal that the artist was both like a travel writer and a performance artist, engaged in a lifelong journey to psychogeographically chart Yorkshire, Germany, Italy and the light in a patron's country house at Petworth.

Road movies are a whole cinematic genre based on the idea of characters travelling. In real life, buses, trains and other forms of public transport are good places to overhear conversations – the basis for a lot of artists' work.

For the illustrator, reading is travelling. Imagine the scene in the text: at what points do you choose to make an image? Drawings of people looking out of windows are images of people thinking about their situations. Drawings of people having fun are images of people in the moment.

We must resolve not to stay in. To go somewhere with art, you have to go somewhere *with* your art. Inspiration and travel are bedfellows because discovery of new places and new ways of doing things shows us that our everyday habits of thinking are born out of one perspective. The limiting, hermit-like nature of human understanding is profound.

Travel is physical juxtaposition. When travelling, you are using yourself and your own performance as a human being as your material. I like to write in public places. Today I am in Margate sitting in the very same wind-shelter-come-seaside-bus-stop in which T. S. Eliot wrote part of his modernist miserablist masterpiece, *The Waste*

'GO SOMEWHERE AND TELL US ABOUT IT'

Land (1922). The lines he wrote in this shelter were 'On Margate Sands. / I can connect / Nothing with nothing'. Is that inspiration or pessimism? I find it inspiring sitting on the same wooden bench as Eliot. He was writing about the bleak sky and the grey sea, but today it's sunny and I have the buzz of ideas sweeping through me. I am alive with expectation.

HEURISTICS

Improvisation often leads to inspiration. It's all about the collision of juxtaposition with serendipity. Collisions are important. By playing with forms, ideas, colours and gestures, one develops a plastic process. It's important to have a plastic process rather than a rigid one, so that you can go on an inspirational exploration.

A plastic process is one where the parameters can be changed. In everyday life, this is called 'shifting the goal posts'. It's generally frowned upon. You're changing the agenda – you're not doing what you set out to do. But it's often more useful to acknowledge that what you set out to achieve is limited by the thinking you were engaged in when you set out to achieve it. *Uproot goal posts!* Life is an education, and learning from it is important. Learning as you go is called 'heuristic' learning, and most art practice is about this process. Think of Picasso, or indeed any artist who is any good, and you will see someone who has travelled over a vast terrain of ideas over time and the shifting of relationships. Picasso was creating a new language for art as he travelled, and he was inspired by life (though in *Guernica*, arguably his most important work, he was inspired by death).

STIMULANTS

Artists need stimulants. Coffee, reading, libraries, galleries, the radio, TV, other art and booze are important, though stay off the hard stuff – it's a waste of time; art is transcendental enough without giving yourself hepatitis. Make it a high priority to sort out a time and place to work. A studio can be a computer – these days this is often the case – but the way you work is still important. Thinking about

How about this...?

MAKE AN ABSTRACT PAINTING

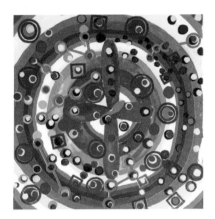

First, develop an abstract musical notation, using colour to represent the scales, with red representing the note G.

Next, make an abstract painting that is based on a section of your colourful musical notation artwork. The second exercise is about making visual decisions.

DEVISE YOUR DREAM STUDIO

If you could have everything around you that you need to make art, what would you have and where would you be? I want you to paint your absolute dream studio. Is the studio modest (a shed in the garden), or grandiose (a castle on top of a mountain in Bavaria)?

your environment and recognizing what works for you is crucial to acknowledging the key elements and the make-up of your hinterland of inspiration.

DREAMS

When I graduated from my postgraduate course, I made a model of my 'dream studio'. It was located on the border of Wensleydale, Umbria and New York. Steam trains came daily to pick up works and, although it was inland, it was also magically by the seaside. To take a break I would walk with my toes in the sand and for inspiration stare at the sea.

My dream has come to life. My studio is in Ramsgate – I can take breaks to look at the sea, and I travel to Ramsgate on the train. It's all about artistic affirmation. Perhaps artists are affirmationists. My real name is Patrick Brill, and life has been pretty good so far.

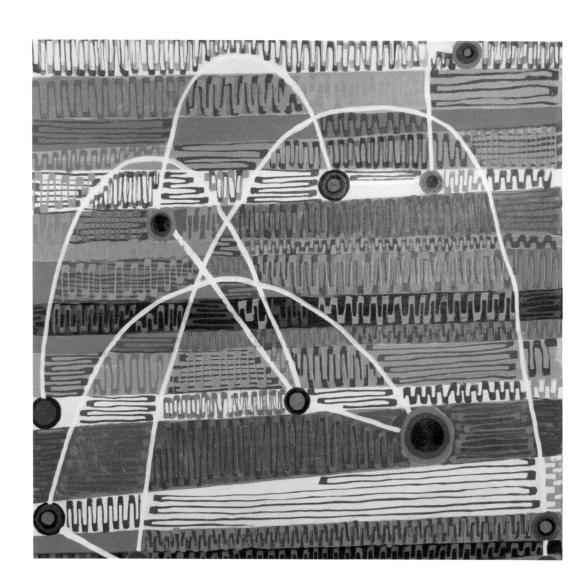

CHAPTER

2

LOOKING

DISCERNMENT

Art is looking. Looking at the world with concentration and humanity, looking at language, and looking at forms of art itself. It requires an understanding that saying something is one thing, and the form in which you say it is something else. Sometimes the form in which you say something is indeed the thing you want to say. Either way, art is not so much what you say as how you say it. Your reaction to the world is also a part of the world as a whole. By offering something to the world you are being critical, while making a contribution.

Depicting aspects of the world is the mainstay of your new activity, but you are also now participating in it. Deciding what the world needs is important. This can only be done through looking. Looking is political. Looking is about governance. We look at the world and we make judgments about what we see. We all see things differently, and our diverse viewpoints are sacred. I am not a religious person, but I believe that how we see things is all we have. We have a responsibility to look carefully with sensibility, sensitivity and understanding.

ILLUMINATION

Caravaggio's great innovation was to shine light into paintings. The light he shone represented the light of the voice and stewardship of God. We talked about synaesthesia in the introduction to this book (p. 17). It's here again. Light is the voice of God. In the paintings of Caravaggio, light might be shining to reveal something pretty horrific – John the Baptist's head on a plate, for example. Nevertheless, it is always light that allows human beings to see.

Looking can be a tool for us to say, 'Oh I agree with this. I celebrate this. Let's have a party.' Often, however, it is the act of looking that leads an artist to be sceptical of the status quo.

On a recent episode of BBC Radio 4's *Front Row*, I was asked if artists were getting more political. I answered that this was the wrong question. In the UK, we are living through polarized political times, and the field of art itself is becoming political. Our current government has spent ten years telling children that art as a subject is not worth

SET UP AN EASEL IN FRONT OF THE TV

Look at shifting images on the TV screen and attempt to make a painting from them. This exercise is about impossibility, but it is also about looking and making judgments. After an hour of attempting this, you will have produced something. That 'something' will be the result of your decisions about what was important visually while you were looking.

How about this...?

BECOME A RAT TRAPPER – MAKE A TRAP

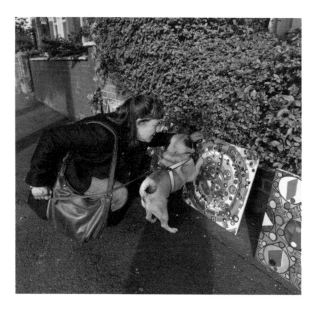

Make a series of small paintings. Put them outside to see if anyone will take your art. Which artworks will be taken? What will you be left with, and why?

studying. That makes art political. Artists maintain the right to be sceptical. That's why so many artists living in repressive regimes end up incarcerated.

In 2018, protesters against fracking and those speaking out against enforced extradition were charged under terrorism laws. These protests had more in common with pacifism than terrorism. None of the protesters looked like they would hurt a fly. They were probably vegans. There was no need for such a heavy response to their actions other than to frighten others. Protesters were being used as examples. In the seventeenth century, the Tolpuddle Martyrs were deported from Dorset to Australia for the same reasons. They wanted to form a union of agricultural labourers but were charged under conspiracy laws. Their extradition was a political gesture to tell destitute workers to think again before they got together to ask for proper pay and conditions.

Why, as an artist, am I so concerned about this? Well, it's because protesting and being an artist, a journalist, a novelist and a poet are all about free speech. We are all engaged in a game of 'free expression'. But really it's not a game – it's about defending democracy.

MAPPING

In the 1960s, psychologist Tony Burzon devised the 'mind map', or 'spider diagram'. This was drawing from listening. Burzon was trying to synthesize the lectures he was listening to. Mind maps understand drawing as a way of working things out and assimilating ideas.

Drawing is a first chance. This is why it's so important in schools. Drawing can be a rehearsal as well as a result. Without drawing we drive down cul de sacs. Without drawing we fail to think through our plans. Devise and conceive of the world through drawing. Looking through drawing allows us to collect evidence and amass information.

INTERPRETATION

Eighteenth- and nineteenth-century landscape painters like Turner drew 'en route' in sketchbooks. They were drawing in the landscape; the sketchbooks were notebooks. Turner's and Constable's sketchbooks are works in both text and image. They gave the artists lots of information, but not all the information that was needed to make larger paintings. Rather than providing a blueprint, the drawings or sketches gave a basis for further improvisation. The gap between the drawings and the finished paintings allows us to witness the artist's *interpretation*.

Here we have a key equation:

Interpretation = looking based on facts + invention based on improvisation.

This equation enables human beings to make and design objects, develop ideas and improve our situation. It creates the space for creativity and is the architecture for what we like to think of as *artistic freedom*. Using this loose equation, artists give themselves authority, through looking and researching, to extemporize and innovate.

BEAUTY

The world is horrible and the world is a place of – unimaginably, tantalizingly – sublime beauty. You can make an ugly painting of something beautiful (you probably have done already), and if you are a great artist you can make something beautiful out of something horrible (like that portrait of John the Baptist's head on a plate by Caravaggio). But artists can also make beautiful images of beautiful things. The idea of the 'sublime' is wrapped up in this dialogue. Turner gave it a go. Art is about confronting these impossibilities.

'Don't replace cannot with don't replace cannot with don't...' You cannot paint a sunset, you cannot paint heat, you cannot paint a frozen lake, and you cannot paint God. It is impossible to paint God, even if you believe in him. Turner's images of sunsets are not sunsets. They are

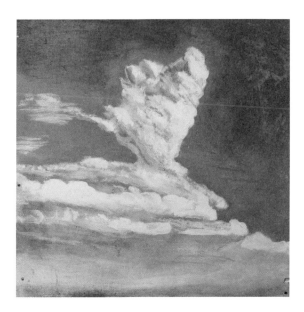

not even remotely like sunsets. They are flat, quotidian bits of wood and canvas with paint on. Artists are energetic, but we can't create energy.

The sublime is the gap between what we can see and what we can do – the 'real world'. An artist's skill is to make impossibility visible. The literal-minded iconoclast's crime is to have no sense of the joys of ambiguity or irony. Impossibility is beautiful. Literal-minded iconoclasts, who have smashed up monasteries and scratched out icons, blown up Buddhas and wrecked Palmyra, want to say: 'Not only can you not make an image of God, but human beings cannot make things beautiful.'

That's where they are wrong. Not only can human beings make beautiful things, the desire to make beautiful things is both deeply human and deeply beautiful in itself. For those who believe in a god, the act of making images and artefacts is a prayer. For those of us who don't believe in any god, the universe is no less magical and mysterious. Art is our way of expressing our wonder.

A unique challenge is to paint a beautiful thing that is 'impossible' to represent. Above is a cloud that I saw briefly through the window of a train bound for Basel. I had just eaten a delicious meal of slow-cooked lamb and dauphinoise potatoes in a restaurant called Le Train Bleu in Paris. After a nap on the train I awoke to see an amazingly tall, triangular

How about this...?

WRITE AN ILLUMINATED LETTER TO A POLITICIAN

This is a placard I made and used as part of my campaign for the arts when I stood in the General Election of 2015 against the British politician Michael Gove. Gove was responsible for reducing the scope of arts education in the UK. Who would you write to, and why? How would you catch their eye?

cloud. I reached for my sketchbook and drew. The painting was made in my front room in Leytonstone. It's nothing like the cloud I saw.

Looking is governance. It needs light. Just as Caravaggio's art needed light, so art in the twenty-first century needs light and freedom if it aspires to be true.

INSPECTION

In the Umbrian town of Sienna there is a decorated parliament chamber, which includes a series of fresco panels called *The Allegory of Good and Bad Government*, painted by the fourteenth-century Renaissance master Ambrogio Lorenzetti. It is a work of propaganda in a town hall – a blunt instrument reminding law-makers and local officials of the ramifications of their decisions. It is beautiful and inspiring. As one enters the chamber, the magnificence of a social system in perfect order is revealed. Farmers harvest wheat, plump sheep wander the fields, commerce takes place in the markets, and all is well. Turn to look at the wall opposite and you see the same town in disorder: the buildings are crumbling, the oxen are starving, and the landscape is populated not by sheep but by warring soldiers. The installation reveals the virtues of good government and the vice of fractious and corrupt rule.

On another episode of BBC's *Front Row*, the critic Jonathan Jones challenged me to name one work of art that has changed politics. I replied that the immediate agency of art in politics is only one question. Another is: how do we remember the bombing of Guernica without Picasso? If Turner had not imagined the slaves thrown from the slave ship *Zong* in his painting *The Slave Ship*, we would have no image of that crime. Lorenzetti was more powerful and is more remembered than anyone he depicted. His art is his power. His power is drawn from his humanistic inspection of politics. Art may not always change politics in the way that the artist intends, but art is part of the whole political landscape and it is always deeply political.

When you make a drawing of the world, you are with these great artists and your pencil is your torch, shining light into darkness. That may sound over-the-top but it is true. And truth is beautiful.

STEALING

HABIT

We are imitative beings. Our experience of the world is so crucial to our sense of who we are that we cannot help but adopt some of the characteristics of the people in our lives. We are also shaped by events that envelop us. If shocking incidents happen close to us, they affect our lives. If joyful, rich, nurturing experiences fill our days, we are happy and good-natured.

Habits are important. The sense in which we can easily become habituated to certain ways of thinking and behaviours cannot be overstated. Some educationalists are now thinking that there are creative habits we can learn. I think we should get into the habit of blatant theft.

APPROPRIATION

Appropriation is all about theft. Human beings are thieves. We steal others' ideas. We feast on the flesh of others' thoughts. All animals feast. It's how rats get bigger, and it's why flies thrive. It's also how human society progresses. Eat, eat. Steal, steal. Progress, progress.

We worry about theft, in art as in society. To identify ideas in art as stolen is to undermine the art and the artist. We counter theft with positive ideas of originality. We have invented 'copyright' just as we have invented 'industrial espionage'. But imitating others and stealing ideas is how we learn. So I say go out there and thieve. Pinch ideas from your contemporaries. You will find out if you can realize them better, or whether they have something you cannot improve upon.

In a culture where sharing has been digitized, we are familiar with the idea of appropriation, but we may not realize that it is key to almost everything we do. As we appropriate, we innovate – we alter things, we get it wrong, we get it right, we synthesize ideas into something else. That 'something else' is something new.

The stealing of cultural ideas has always happened in plain sight. Picasso stole from everyone around him – he stole from the Greeks, the Romans and the Etruscans. He stole from Braque and Cézanne, and at the end of his life he stole from the French TV show *The Three Musketeers*. Yes, Picasso painted from the TV too. Then everyone started

How about this...?

STEAL SOMETHING

 I am not asking you to consider a major theft here, nor am I trying to get you into trouble. This exercise is about thinking about learning. When we learn, we are in some sense mastering and replicating others' works and ideas. To use a cliché, we are attempting to climb on the shoulders of others and benefit from their hard work. If you are brave or mad enough to steal an actual object, what you have done is make a declaration to yourself that you assert ownership over an object. You have conferred on the object an ambiguous and nefarious condition. It no longer knows who or what it is.

 Don't steal an object – steal some ideas. Make an artwork that is based on the ideas of an artist you admire. I like the idea of artists as scavengers and thieves because I think the scavenger operates on the outside of society and picks up what is useful to him or her to earn a living. Reshaping and repurposing ideas is what artists do.

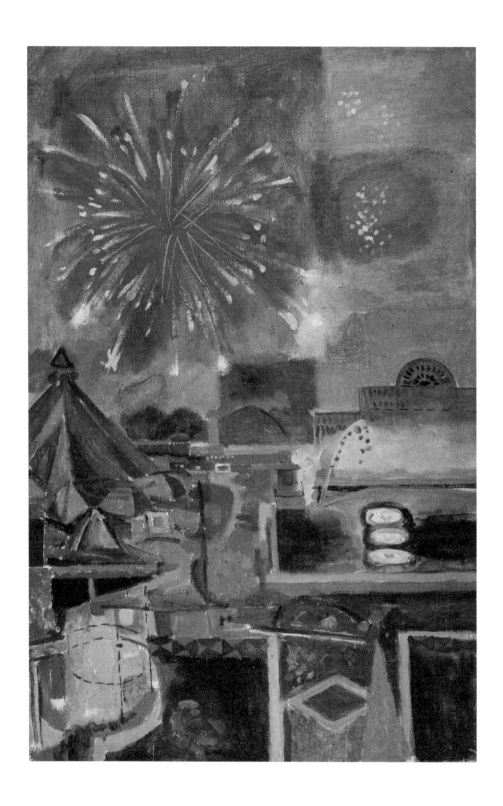

Chapter 3

stealing from Picasso. Henry Moore built a life's work on Picasso's classical period. Graham Sutherland pilfered from Picasso and gave us the magnificent stained glass of Coventry Cathedral. My father stole from Picasso. Opposite is his image of the 1951 firework display at the Exhibition of London. After the war, the first retrospective of Picasso came to the UK, and it changed British art. Armies of art students like my father went to see the exhibition. It liberated British artists from gloomy, accurate portrayals of what they saw and introduced them to a new world of pictorial ideas.

EXPLOITATION

Appropriation is not always positive. The thing that has been appropriated often loses its original meaning: where the blues was about pain, rock and roll was fun. When we appropriate from another culture, we should remember that we are not doing that culture a favour – in almost every case, we are doing a favour for ourselves. European modernists were credited with inventing something new when they came up with abstraction, but one of the things they had actually done was appropriate African geometric patterning from masks that were being traded in Paris at the turn of the nineteenth century. The West got the blues from Africa, and it got modernism from Africa. The story of trade with Africa is a shocking one – unequal and inhumane. Here the acts of stealing and appropriation are corrupted by exploitation.

In our own time, Facebook steals. They call it 'sharing', but it is we who are doing the sharing while they are doing the learning, as they mine our data. Facebook is like the great brain and we are its senses.

But art students are put together in large, open studios to enable theft. They may or may not steal paintbrushes and paints, but they do steal ideas. Without realizing it, they each become teachers as they steal from one another. If we realize that stealing is also generative, we can understand the exploitative process and capture some of that magic for ourselves. Stealing is understanding. Hacking and jamming involve the same intelligence.

HACKING

In Jean-Luc Godard's wonderful 1965 film *Alphaville*, a gumshoe detective is sent to a far-off planet (which is actually Paris – all the Citroën cars back then looked like spaceships, so it works really well). The detective is sent to understand and destroy a cruel and evil civilization. His aim is to liberate the citizens of the planet from the mind control of central computer 'Alpha'. The people of Alphaville do nothing but work. Their lives are joyless and unfulfilled. Relationships are forbidden. Our hero concludes that the way to 'hack' into this system is to tell Alpha a riddle that involves something it cannot comprehend – poetry. In another seminal sequence, the daughter of the creator of Alphaville, with whom the detective has fallen in love, recites lines of poetry by Paul Éluard, taken from a book the detective has given her. Ultimately, Alpha and its planet-wide tannoy system crashes. At the end of the film we see that hacking is art; poetry is jamming. Artists are hackers in the world of work.

I want this book to be the hacking catalyst that urges you to find a quiet space and start making, drawing and devising things. Art is seen as subversive but it need not be, should not be. We should all be hacking systems and falling in love through art. This chapter has developed, as I write, into a plea for art as inappropriate behaviour, and the artist as an undesirable to be cherished.

FREEDOM

If art is undesirable to ordered and repressive societies, it is because the artist is an assertive presence. Graffiti is the physical, sometimes joyous and sometimes angry, manifestation of the assertive artist. From cave painters to prisoners carving on the walls of their cells to kids tagging subway trains in 1970s New York, artists have wanted to assert their presence. These artists talk to each other as effectively as they talk to us. They talk in a rush of subversive carving and spraying.

Graffiti art on the New York Subway is so appealing because we can see its styles emerge and merge in virtuosic flourishes of colourful, competitive jousting. The dark side of graffiti art in New York

How about this...?

LEARN A SONG

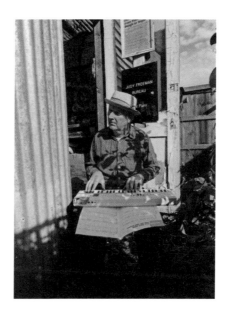

When learning a song, it is interesting to speculate as to what exactly is going on. The song itself is immaterial. The important thing is that the song lives in the voice of the interpreter. There is little point in romancing about unrecorded performances, because it is the echoes in a performance that are interpreted where a song lives. Learning is stealing. In the case of folk music, the story is about shared and polyphonic resonances. When a folk song is written down, it may be given a life that seems fixed, but it is only one that is captured at a particular point in time.

How about this...?

IMPROVE AN OBJECT BY PAINTING IT

This exercise is about the nature of art as an action. Paint a window frame. Re-paint your front door. Paint a chair. Decorate something precious for someone else as a gift. Paint a card for someone you love.

RUIN AN OBJECT BY PAINTING IT

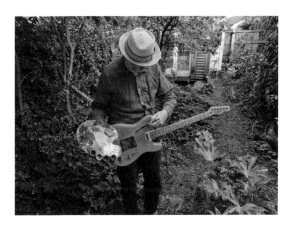

In the 1960s, when orange and turquoise were invented, my mother set about modernizing the dour colour schemes in our house. I had a beautiful but rusty bicycle that was painted in a burgundy and ivory livery. It had been my older sister's, and I was proud that I was now riding it. One day I returned home from school to find my mother had given the whole bicycle a single coat of bright orange paint. She had painted our two beautiful Windsor chairs orange. She had painted biscuit tins orange and half-painted the fridge. She had become a domestic vandal armed with a brush and a tin of orange gloss paint.

A quick coat of paint can make a beautiful object ugly. Re-decoration is all about purposeful transformation, but my mother's aspiration was skewed. Our house did look more modern – it looked more 1967 – but my mother had also defiled it with misguided contemporaneity. Try ruining an object of your own with paint. State your purpose in the transformation, and see where it takes you.

How about this...?
MAKE A TRANSCRIPTION

Copying in art is good. Copying an artwork lets you understand exactly how skilled and masterful you have to be to make art. The Tate and National galleries in London encourage young artists to sit with a sketchbook in front of masterpieces and attempt to divine their secrets. It has become fashionable to engage in the act of slow looking. But to sketch in front of a masterpiece in a gallery is to learn quickly that art is an ineffable and mysterious thing.

and Chicago was that the tagging of territories was often carried out by gangs and felt to many like a frightening loss of control over the public realm. But in another sense graffiti artists were carousing with the city – with music, particularly hip-hop – in a dynamic expression of pent-up creativity. Artists breaking the law move beyond the law, in a free space beyond the norms of society.

REPRESSION

In democracies, there is a necessary separation of three main powers so that one group in society cannot rule the roost. The Executive cannot operate beyond the laws of the Judiciary, which are in turn devised by the Legislature. Artists, writers and musicians constitute a fourth strand to this set-up. They are like society's natural spirit, offering pure, free expression beyond the norms and rules of the Executive, Judiciary and Legislature. This is why making art can be a dangerous act, and is threatening to governments. For some governments, art is considered to be in need of control and sometimes outright suppression.

We are inspired by artists in their resistance to repression. Artists are inspired by other artists, and in turn set a trail for others to follow. Graffiti artists set a trail across communities from one side of town to the other, and artists like Van Gogh, Picasso and Frida Kahlo set a trail that has continued to inspire artists for decades. So go out with your swag bag and steal – just don't steal money or cars... or loves.

THINKING

CLEVERNESS

Truly abstract thinking is impossible. When we think, we think about something – numbers, concepts and truths. The language we think in is part of the whole thinking process. That's why *abstract art* is often preoccupied with its own existence. It is, itself, a language, with numbers, concepts and truths behind it.

Clichés like 'inspiration exists, but it has to find you working' are true. Thinking is like chewing. Tasty food needs to be in the mouth. I grew up next to a farm right up in the Yorkshire Dales, miles from a library, school or hospital. I had a favourite cow. Her name was Jack. Jack and I would look each other in the eye. Jack would be chewing. Jack would be breaking down grass. I am sure Jack was contemplating the spotty kid who was gazing at her.

That pasture was an art school. The whole world is an art school. To conceive of the whole world or the universe as an art school is to say that everything requires contemplation. We are all students in a large studio looking at each other's art, and we all contemplate what is to be done. Blank sheets of paper ask us to fill them with visions. When you give blank paper to children, you are inviting them to construct their worlds. Blank paper will be filled with the voices of the future. For human beings living in caves, raw speech turned into communities of words, which became language. Visions became a world of actions, art and artefacts.

Images occur in our mind's eye while we work and while we dream. Writing down those images or dreams involves translation, and may be useful for the Freudian psychoanalyst, but nothing could be more direct than if we were able to paint those images. Some artists have tried this, most famously Salvador Dalí. Filmmakers like Luis Buñuel have constructed dreamlike sequences in an attempt to look into the mind's eye. Dalí, Buñuel and, more recently, David Lynch have tried to depict how the mind works via the image of the 'dream', but of course we can see the human mind working, thinking and solving problems every time we look at a bridge or get on a train or look at any painting that has ever been made.

How about this...?

DESTROY SOMETHING AND MAKE A TECHNICAL DRAWING

Drawing is about understanding. In this recipe, I am asking you to destroy an object by taking it apart, and in doing so I am asking you to make something. Art and knowledge can be about destruction as well as creation.

Make a drawing that tells us the story of the object. The archaeologist knows that all archaeological digs are acts of destruction with the goal of understanding. In the 1970s, punk was about the destruction of music. The post-war works of the German Jewish artist Gustav Metzger were meditations on destruction. His family were destroyed in the Holocaust, and his works include images of the artist dressed in a gas mask spraying acid onto surfaces which decayed and dissolved before one's eyes.

I am asking you simply to take apart a clockwork toy or kitchen tool and to create a drawing that documents the parts. Is making your drawing harder than destroying the object?

How about this...?

PAINT A DEAD RELATIVE, NOT FROM A PHOTOGRAPH

Like the folk singer that carries a song in her or his heart, we all carry within us images of the dead. I can remember my father's face although he died thirty years ago. I can picture images of my mother in each period of her life from the mid-1960s, when I was born. Painting a face from memory is a difficult thing to achieve. It is truly conceptual art. There is no one, just your mind's eye, that can be the judge of your skill. This exercise seems therapeutic, but in fact it's about self-criticism. Only you can be the judge of your actions. This is an acid test of your critical powers.

Our problem with Jack the cow is not that she was not thinking; it is that she could not express herself by making a painting or building a bridge. Art is the expression of thought. Jack the cow was not an artist.

SENSE

Stroking a painting is a kind of communication, rather like chewing – impossible in a museum, but possible at home. I often touch artworks I love. I hold the side of a painting by my mother. She died recently, but we can still talk to each other and exchange ideas. The conversation is not one-sided. She is talking through her images. Touch, smell and taste aid contemplation and cause revelations. Ask Marcel Proust. Writing this chapter on 'thinking', I am stroking my chin and I am desperate to smoke a cigar. I stopped smoking cigars thirty years ago. I will go and make myself a strong espresso instead, taking time to grind the coffee and heat the milk to the correct temperature – taking time to think.

Making art can be mindless and at times seem pointless, but it is also hard work. Like chewing, it can be revelatory and marvellous. Thinking is ordering, imagining and re-imagining; imagining ideas, materials and stuff – objects. Everything needs to be thought about. Like Jack the cow, chewing and thinking about me, we all need to think more.

SPECULATION

Talking to yourself and engaging in 'free speculation' is critical. I once interviewed the British political cartoonist Steve Bell. He told me that he invented the voices and characters for his cartoons by talking to himself. 'Talk to yourself out loud when no one can hear you – even scream or giggle' is perhaps the most useful piece of advice there is to offer the creative individual. Talking to yourself can be *reportage*. Shout out what you see. Report on what's happening. Imagine you are a BBC reporter at a royal wedding, or a football commentator. Talk to yourself as 'post-hoc' rationalization. Defend or explain your or others' actions as an advocate or, even better, as a prosecution lawyer. See the world as a story, linking events with narratives. Be inventive as you speak. In the last chapter, we talked about stealing as a metaphor for

researching. When speaking out loud, lie outrageously. Lies by their very nature are inventions. Make and shout out your extraordinary plans and, finally, confabulate. Confabulation links the whole imaginative process of intellectual reverie together. It's OK to make things up; that's what artists do. Talking out loud is imaginative and speculative. Do it. *Do it now!* I am speaking out loud as I construct this sentence.

SYNTHESIS

Epistemology is the study of knowledge. Philosophers talk about an episteme as a bite-size unit of knowledge. Epistemology is why we talk about memes as if they were ideas with legs. *Ontology* is the study of being. 'I think therefore I am' was René Descartes' great epistemological and ontological statement. It has itself become a meme. It has been adapted and utilized by artists. Barbara Kruger most famously corrupted the meme in the form, 'I shop therefore I am'. Knowledge crashes into a very human reality in this statement. To say 'I shop therefore I am' is to acknowledge that our thinking selves are synthesized with all aspects of our physical presence – what we do, as well as our identities and contexts.

DYSMORPHIA

I know I weigh 12 stone (168 lbs/76.2 kg) but only because someone invented the weighing scale and cruelly calibrated it so I could compare myself with others. *Weigh yourself.* Thinking about your weight might engender body dysmorphia, but like looking in the mirror it is a confrontation between our intellectual self and our physical self. The great thing about grabbing hold of your innate nature is that you will come into contact with the possibility of altering these relationships creatively though art.

The French artist Orlan has even gone so far as to alter her physical self in the name of art. In the 1990s she underwent an operation to insert two small horns into her forehead. Orlan's statement was a celebration of her will over the fact of her physical existence. Artists are wilful.

Art is physical thinking. Thinking can be a very personal thing, a solitary exercise. We don't verbalize all our thoughts, and nor should we, but making art allows those thoughts and ideas that you have decided to express to maturate, evolve and exist without your presence.

SUPERPOWERS

Architects have a superpower, in that we all live within their ideas. In the nineteenth century, A. W. N. Pugin, a Catholic architect, put his mind to creating neo-Gothic architecture for the Victorian age. He designed the Houses of Parliament as if they were a loony, supercharged cathedral. Why did he do this? Well, in part, he wanted to rectify Henry VIII's dissolution of the monasteries, when the king had asserted himself over the rule of Pope Clement VII in Rome. Pugin saw this as a great crime. The dissolution of the monasteries precipitated the destruction of around ninety per cent of England and Scotland's religious art. In the early twentieth century, developers built the house I live in, adopting the neo-Gothic style. They created mass-produced mullion windows and acres of stained glass to be inserted as decoration in front doors. I live in a house that is a physical political statement by an angry Catholic architect.

Engineers also enjoy a peculiar superpower. We travel and communicate within their concepts. To go on the London Underground is to venture through a treasury of ideas. Designers like Edward Johnston, who designed the Underground's iconic original font, and Harry Beck, who came up with the tube map, projected an outward sense of utopia. The London Underground is a fine example of collaborative thinking by human beings to solve problems over time with great engineering, great design, great panache and great art.

How about this...?

CREATE A DEMOCRATIC PAINTING

Divide a painting into sections. Fergal's loop drawing in the first recipe (p. 23) could be a good basis for this exercise. Now, with a group of fellow artists, decide the next steps for this artwork. One person should be the painter; another person should be a convenor, making suggestions of how to proceed; the others should vote on suggestions and put forward ideas. This exercise is about method and looking at an artwork in progress for clues as to how to proceed. It is a methodological approach.

ITERATION

We need everyone to think. A good way to encourage everyone to think is to make objects, devise events, write plays, create music, and speculate about physics and the universe in every way possible. Thinking is an iterative process. To think through ideas can take a lifetime and require steps along the way that are built upon – sometimes by you, and sometimes by others. The more of us that can put our minds to a problem, the more likely we are to find a solution.

FREE WILL

I once decided to stand against a politician in an election because that politician had decided to marginalize the arts in schools (see p. 48). His thinking was that we needed to concentrate the minds of our young people on mathematics, the sciences and learning to spell, in order for them to find a job. My point was that we needed to concentrate young people's minds on the arts and creativity, so that they could *create* jobs. Numerous studies suggest that a broad education is good for society and democracy.

The MP's constituency was in Surrey Heath, close to Heathrow airport. I didn't know the area well, so I asked the psychogeographer and writer John Rogers to research and tour the neighbourhood with me. His idea was to use Guy Debord's Situationist strategy of the *dérive* to show us the way. John used a simple algorithm to lead us. We were to start walking and turn at the first left, then second right, then first left, then third right, and repeat. As we walked the back alleys and car parks of Surrey Heath, we questioned our preconceptions and challenged our prejudices. At one point the algorithm directed us to walk up a carriageway of a busy motorway. I said to John, 'If we follow the algorithm here, we'll probably get hit by a car.' He said, 'Don't worry. Guy Debord's idea is an "open concept". We don't have to follow it. We can decide we've had enough and decide to go and find a café and have a cup of tea.' And that's what we did. We followed a plan, and we ditched the plan.

'ALWAYS CARRY
A NOTEBOOK'

Computers will never decide to go for a cup of tea because they have had enough. I believe in 'open concepts'. Our decision was very human. The algorithm had taken us to places we would never have set out to see. Despite that, I won 274 votes in the election and my opponent won 33,000 votes. He won. The role that the *dérive* played in my attempt to unseat a philistine is a story about how curiosity and research can be governed by chance and arbitrariness. My efforts were unsuccessful, but I learned so much.

BUDDHISM

In the 1990s, I interviewed the conceptual artist Nam June Paik about some kitsch ceramic Buddhas he had smashed. I asked him why he had smashed the image of Buddha. He said, 'No meaning.' I was impressed by that. The arbitrariness that he afforded himself asserted his humanity. It seemed quite a Buddhist act. There is something illogical and beyond real explanation in some artists' work.

When Marcel Duchamp declared a urinal to be a work of art, he was declaring that it was in his gift to do so. The urinal is a thought about human beings' conception of themselves in the world. The declaration of a urinal as art is a statement about the pointlessness of a hierarchy of objects and functions.

THE MOMENT

It is common to conceive of thought as guided and rational, but useful thoughts can come from unsolicited events, at any time or in any space, in unexpected ways. Always carry a notebook.

WHERE
AM I?

PLACEMENT

'Where am I?' is a geographical question. I am now sitting in the Marks & Spencer café, situated on a glass walkway in the Westfield shopping centre in Stratford, East London. The scene is rather like an image from Fritz Lang's famous 1927 film *Metropolis*, in which Lang imagined a futuristic heaven where personal biplanes would be as numerous as cars. Shopping is happening all around me. People are having fun and being entertained.

Why am I here? Well, I love shopping centres like Westfield. If one imagines the central five-storey walkway as Tate Modern's Turbine Hall and the shops as galleries, you would have to concede there is a lot more colour, light and life in Westfield. The restaurants are cheaper and the cafés more numerous and better than at the Tate. I can eat jerk chicken or Indian street food, sweet and sour pork balls, pizza, burgers, sushi, sashimi, and fish and chips. 'Give the punters what they want' is the ethos, and I like it.

I often come to Westfield to think and write. It's not quiet but it is anonymous. The audience looks a lot more like the London I know than the audiences of art galleries. The voices are my voices; estuary voices talking about everyday hopes and fears. The difference between here and galleries like Tate Modern is that there is nothing on display in Westfield – not a burger, nor a coat, nor a cover for an iPhone – that is not for sale. It's all about desire, and the journey from the shelf or coat hanger to the till.

A major museum, on the other hand, if it's any good, will be an anti-shop. There will be a lot of things you would not want on the walls of your home. There will be some things you never wish to see again – difficult things, troubling things, artworks that ask you questions you might never be able to answer. The ethos here could be: 'Give the punters what they don't know they want, but that perhaps they will need later... we hope so.' Art is not entertainment; it is a serious business bound up with our rights as human beings and the magic of our potential. At Westfield, objects that make one feel uncomfortable are left on the coat hanger and are of no use to the shopkeeper. Recently

MAKE A SHAPE SANDWICH

Pile up a series of coloured shapes. You can add patterned fabrics. Leave spaces between the shapes so the colours underneath can be seen. This exercise is about reflecting on how paintings are made in layers.

MAKE A
CORAL PAINTING

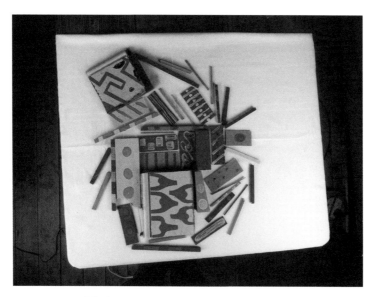

Matisse and Picasso broke down what came before them. They did this by conceiving of canvases not as stages to be filled with motifs, front and back, but more like children's jigsaw puzzles where everything lives on the surface. The painted surface is like fractured ice on a lake. These artists' interest was in the picture plane; the surface.

Take the shapes you made in the previous exercise (p. 77) and throw them arbitrarily on the floor. This is how Matisse's great *The Snail* (1953) was conceived. *The Snail* is a beautiful, harmonious spiral of primary and secondary colours. Matisse threw down the shapes and then adjusted them to build the composition, which is a playful collection of 'meant' and 'found' relationships.

I visited a retrospective of the war photographer Don McCullin. Someone asked me if I enjoyed it. I thought, 'How can you enjoy images of dead Vietnamese and starving Biafran children?' I said that I hated the exhibition, but that I was glad I had seen it.

So where we are, what we are expecting to encounter, and how we operate in our environment is important. It's all about context – ideas that are around and about.

COMPOSITION

I am thinking about the question, 'Where am I?' as a pictorial and formal question of location and composition. Paintings are made in a combination of two ways, leaning more in one direction than another depending on the artist. Paintings are like a *sandwich*, or they are like a *coral reef*.

Traditionally, they have been built up in sandwich-like layers – first the canvas, then a layer of neutral colour called 'the ground', then the main painting, and last the inflections of dark and light in which areas of deep shadow come first and build to highlights and reflections. Painters build up a drawing, then tone, then colour and, finally, light – broad skies and sweeping landscape, clouds and trees and other details. This is called 'figure-ground composition'. It's how Turner painted, and how Michelangelo painted.

Paintings can also be like coral reefs, with shapes and forms that emanate from each other and exist beside one another, creating compositional patterns. 'Coral reef painting' is a modernist phenomenon, but it is possible to see it in complex history paintings from the fifteenth century, like *The Battle of San Romano* by Paolo Uccello. Matisse is the most obvious modern example of an artist working in this way. His cut-outs are made exactly like this. His great work *Oceania* is an image of the sea, so we can feel its references to coral very clearly, along with its organic and developmental composition. Everything is happening on the surface. Joan Miró also worked in this way. Playing with elements in a coral-like composition allows shifts in weight, form, pace and balance. The picture plane is cherished and acknowledged. Vija Celmins, the

obsessive contemporary artist who depicts the complexities of *everything*, from the universe to pebbles on a beach, works in this way too.

CONTEXT

'Where am I?' is a question about context. My love of Westfield shopping centre in Stratford is confined to its visual and social spectacle. Its aural qualities do not charm me – shopping centres can be incredibly noisy – but Westfield undoubtedly plays a flagship role in the regenerative economy of London's Olympic Park. If I were to make a series of paintings of my favourite shops and light displays, I might be accused of unthinking collaboration with the whole enterprise. But artists pride themselves on knowledge both of themselves and of the contexts in which they operate.

Art schools love the idea that making art encourages 'critical thinking'. But critical thinking about what? Power? The role of the artist can be rather like that of either the high priest or the jester in a feudal court. It's easy to see artists in this way. Many of the Young British Artists who came to prominence in the 1990s seem like chameleons inhabiting the jester and high priest roles simultaneously. An artist like Ai Weiwei works defiantly in the high priest mode, protesting and pointing out injustice and corruption through works of art. Jeff Koons – with his oversized, children's entertainer, shiny Balloon Dogs – has become the world's court jester, amusing us with his art pranks. Artists locate themselves in a cosmos where power, recognition and celebrity seem to emanate from central points in the world's capitals. Artists orbit these with varying degrees of illumination.

Just as artists draw power from contexts, so too do OBJECTS. Marcel Duchamp's removal of various pieces of French ironmongery, like bottle-drying stands and bicycle wheels, from the shop to the art gallery were experiments in the power of the artist to change the context of objects. Similarly, the Icelandic artist Olafur Eliasson removed ice from the Arctic and displayed it in front of Tate Modern in a dramatic and poetic display of how we want and need some objects to remain in their natural surroundings.

'ART IS NOT ENTERTAINMENT'

NAZANIN ZAGHARI RADCLIFFE DETAINED BY IRANIAN GOVERNMENT

Context can be about SCALE, too. Standing at the base of the Pyramids makes you feel small. So does wandering through the entwining legs of an enormous bronze spider, complete with white marble eggs, as created by Louise Bourgeois.

Context can also be about GEOGRAPHY. To visit Italian churches and see great masterpieces, like Piero della Francesca's *Madonna del Parto* in Monterchi (*c.* 1460), is to engage in an art pilgrimage where one quickly realizes that the Italian Renaissance was deeply rooted in the country's landscape. As one leaves the chapel, the warmth of the light one sees in the paintings is experienced bodily.

Context can also be about HISTORY. Herbert Read wrote his great masterpiece *Education Through Art* in 1942. As I have done in this book, he mentions the events of the day while he writes. In Read's final chapter, 'The Necessary Revolution', he writes as he has just heard of the destruction of Cologne by the British air force. This leads him into a reverie on man's capacity for destruction. He calls this 'insensibility', and rails against it. His suggestion is that a thorough education in the arts will awaken in the child a deep and formative awareness of his or her environment. *Education Through Art* is all about the means to create the conditions of a new environment for the child. Read argues that a nurturing and supportive education would decrease the war-like tendencies of human beings and promote our capacity to see and make beautiful, good and truthful judgments and objects. Art education has often been promoted in the aftermath of war. Franz Cižek, the Austrian painter and woodblock printmaker, developed the Child Art movement following the First World War. He saw children's art in this context as an antidote to the violence.

Ideas are contexts. Governments are contexts. While Herbert Read was writing *Education Through Art*, others were speculating on different ways to make society richer, wealthier and healthier. The Beveridge Report, a government document published in 1942, gave rise to the 'welfare state' and the National Health Service. Generations of British children benefitted from these platforms for prosperity. From the 1950s until the 1990s, children enjoyed an art education that had

MAKE A MAP OF SOMEWHERE THAT IS IMPORTANT TO YOU FROM MEMORY

This exercise is about map-making from memory. Recall a complete set of relationships. The map you are making is about the topography of a situation, but it is also about relationships.

How about this...?

MAKE A MAP OF THE SCHOOL YOU ATTENDED AND PLOT THE FRIENDSHIPS YOU HAD

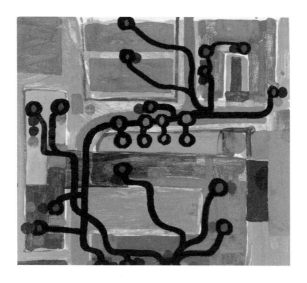

Join the dots. Create relationships between individuals in the space of the school. Did you meet in the playground or in the dining hall? Were you hanging out in the art room or on the recreation field?

Around the sides of the drawing, extend the lines of the relationships to plot where these individuals are now. In the UK, one of the first uses of social networking was just this – a website called Friends Reunited. Perhaps you might hold a reunion to add updated information to your map.

You will inevitably build a rich web of abstract, overlapping lines and shapes when making a work like this.

been inspired by Read's idealism for idealism. I am a product of that period, that context. My primary education in art was informed by a generation of young teachers keen to place our voices as children at the centre of our learning.

Context is EVERYTHING. An understanding of context can reveal how others see us and how we can relate to one another. Understanding the context of art is to understand the truth and motivations of artists. On the other hand, contextual knowledge can stop people engaging in useful and formative experimentation. Context points out the hypocrisies of the artist who professes a social conscience but drives a Porsche. Concern for context shines a spotlight on some artists' desire to appropriate the style and manners of those in power. Still, in some situations we should ease up on contextual awareness, lest we miss the truly beautiful and undervalue great artistry. For those starting out, contextual awareness can be limiting, but it is good to adopt different guises without worrying whether they look good. Contextual gaffes are mistakes which can be learned from. The contextual gaze can always be widened and recalibrated to summon forgiveness. When they are starting out making artworks, we want artists to be irresponsible, not responsible.

BEING THERE

Artists need to stand by their statements, stand up for their artworks, and allow what they have made to have veracity. The person who has lived through an historic event, been somewhere or done the research is always going to be more convincing than the well-meaning person who has been watching the TV. The war photographer has to go to war; the journalist has to tell us what it's like to be there – all the rest is received opinion.

MOVING ON

When does a work of art 'stop'? Does it stop at the edge of the viewer's line of vision, or when the viewer walks away? A strong artwork should aim to continue in the mind of the viewer. Great art should be a virus

GIVE A PAINTING YOU HAVE MADE EARS, OR EXTENSIONS

This recipe explores where the edges of your artwork really lie. It's common in filmmaking now to think of sequels, and even prequels. What would that mean for your art? In creating extensions, you will exploit what you have made, as well as discovering more of its true qualities. See what happens next. Is the edge of something the end of that thing? When does an artwork stop?

If you are a sandwich-making painter (see p. 79), does the end occur because there are now so many layers that the physical thing feels like it's coming towards you? This must happen to Anselm Kiefer, as layers of tar and straw build up on his paintings. 'Stand back!' say the assistants of Jessica Stockholder, whose painted reliefs fill the room. If you are a coral-making painter (see also p. 79), is the painting complete when you simply run out of space?

The American composer La Monte Young devised an unending composition. Brian Eno emulates this idea in pieces like *Music for Airports* and his various oscillating lightbox works. Finishing a piece of art is a human declaration.

that you can catch. Francis Bacon often added side panels to his works; twelfth-century icon stands also have them. Max Beckmann gave his paintings 'ears', or extensions. He wanted to suggest time and narrative, and to do this he added panels to his paintings and turned them into diptychs and triptychs. As one's eye wanders across the work, we move from one disjointed, fragmented scene to another. Our vantage point changes. Beckmann's paintings are not prescriptive views or stories depicting one scene. They ask us to contemplate the artist's plan.

Where you stop as an artist is your decision, and it's crucial to understanding an artwork. When it comes to the final stop, private art galleries benefit hugely from an artist's death. Not only will the pesky artist not pollute their oeuvre with a lot of late works but what they have made becomes finite, a better package, and easier to commodify.

NASTY ARTISTS

Some artists want to see what happens when they insert unpalatable and untested strategies into the world. 'What will happen if I offer to pay poor people to be bricked up behind a wall in a gallery?' asks Spanish contemporary artist Santiago Sierra. 'What will happen if I draw a woman peeing under a tree?' asks Rembrandt. **How about this...?**

BORING ARTISTS

Rather boring artists execute careful, well-worked-out plans. Of course, artists always claim the successes of their plans and disown the failures, but in art, if you have a clear idea what will happen when you exhibit an artwork, the curiosity algorithm has NOT been played out to its full potential. By revealing the context of human actions, we artists are testing the status quo and questioning our surroundings and assumptions.

WHAT IS THIS?

MATERIALS

Making art involves working with materials. The materials you choose determine everything about your art. If you choose to work with ideas, you are a 'conceptual artist'. If you work with language, you become a 'text artist'. Working with clay produces 'ceramic art', and is part of a sculptural language. Carve from wood and stone and you can talk with authority about Michelangelo while building up muscles. Painters use paint. Watercolourists use watercolour. Filmmakers use film (or used to, before film went digital).

The story of art is a story about technology. The Iron Age produced beaten and forged iron objects; the Bronze Age produced shiny, virtuosic, cast bronze objects. Today we are fascinated with digital art, and students present their final exhibitions to bemused tutors while asking them to strap on virtual reality headsets.

The mainstream media is often uncomfortable talking about artists' ideas, which they perceive as pompous and pretentious. The media does not want artists to be experts or intellectuals. Artists, in their eyes, must be artisans and journeymen.

SCALE

If the first attribute of an artwork that the media latches onto is often its cost, and the second is what material has been used, another point of journalistic interest is scale. Sculptures are referred to as the 'largest bronze sculpture ever built' or the 'tallest iron sculpture ever constructed'. Miniature artworks are also worthy of note, as indeed are objects made from precious materials like ivory, blood heads, frozen flowers and cows cut in half. Paintings might be made out of flies. It's evident that some artists are tapping into a desire for the central idea of an artwork to be its material and/or its size.

PAINT

For twenty years I have used enamel signwriters paint. At first, I chose the paint as an ironic swipe at the fetishization of materials by my fellow painters. As I began to master the craft of signwriting, I fell in

MAKE A TIMELINE OF SPOONS

It is good to fetishize objects. I love spoons. Spoons are comic. Knives are not funny, and forks are pointed and utilitarian, but a spoon is a satisfying shape. Before the fifteenth century, spoons were a sign of wealth. Everyone had a knife – to cut with, to eat with, and for protection. Spoons were special, and not everyone had one. If you were invited for a meal, you were expected to bring your own cutlery. A spoon is a good sport, as it allows you to enjoy the playfulness of soups and desserts. Spoons are humanistic objects. Unlike forks and knives, they have been stamped to reflect the joy and sensuality of the mouth. They are also very hard to draw. Draw a spoon.

MAKE A TIMELINE OF UNUSED KITCHEN IMPLEMENTS

Objects accumulate in houses. Over time they become jumbled. A good example of this phenomenon is the cutlery drawer. Or perhaps the drawer next to the cutlery, which is generally filled with unused items of kitchenalia – apparatus for icing cakes, fish slices, lemon squeezers, etc. Get all these items out and arrange them in a timeline of when they came into your possession.

Your arrangement of kitchen bric-à-brac is both Duchampian and Proustian. Like Duchamp, you will have amassed an array of banal but beautiful objects, and like the flavours of a madeleine for Proust, each object will resonate with you in inexplicable ways.

You will have created an arrangement of false hopes, gifts and forgotten passions; times lost, but also cakes and experiences to come. The arrangement will be technical and process-based. Why not use a brush for painting egg yolk on pastries to apply the paint on your next painting?

love with the colour schemes that the paint manufacturers devised for the markets they were serving.

In the 1990s it was still possible to buy enamel paint made in the UK by a company called Bollom. The colour palette that Bollom produced owed much to the Edwardian paint liveries used on railways. There were deep burgundies to contrast with pale ivories, creating the combination rather unappealingly known as 'blood and custard'. Bollom also produced a rich brown to contrast with a warm yellow, creating the more palatable 'cream and chocolate' combination known to travellers on the Great Western Railway in the 1930s. There was Forest Green for garden gates, and Indian Red for concrete floors. No turquoise or orange, because those colours were not invented until the 1960s. Sadly, but unsurprisingly, in the 2000s Bollom stopped producing these paints.

I had to look for another supplier. In New York, I happened across a company called One Shot. The idea is that signwriters are up a ladder and they only want to have to put down one layer of paint in precarious conditions, hence 'one shot'. The paint has a lot of pigment and comes in a dizzying range of colours with exotic names. There is Brilliant Blue, Fire Red, Kansas City Teal and a range of fluorescent colours that would have blown the minds of Edwardian railwaymen. The colours are positively psychedelic. It was after this change in materials that I really began to sell my work. No longer dour and authoritarian, my colour schemes became transatlantic and cool.

ROCKS AND BUGS

The history of paint is a chemistry lesson. First, artists experimented with earth colours like terracotta and hues from other clays. Next came bodily fluids: blood obviously makes a nice crimson, and urine can be used to make a range of yellows. Yellows can also be made from flowers like saffron. Bright red beetles can be crushed up to make reds (cochineal). Sands and precious rocks can be ground to make most colours. Most valuable is a beautiful, endless blue that can be found in late Gothic or early Renaissance painting – this was made from lapis lazuli chipped from quarries in Afghanistan. Sheets of gold were

used in the icon painting of that period, as was inlaid mother of pearl sourced from the Mediterranean. The pigment derived from these methods was suspended in egg tempera and painted onto plaster, then later onto wooden and canvas panels.

OIL

A later innovation was the use of oils to suspend pigment. Oil paint allowed for greater versatility. Artists were able to paint with glazes and create translucent surfaces. In the seventeenth century, developments in chemistry led to the use of more metals and synthetic dyes. Artists like Théodore Géricault and Eugène Delacroix were innovators, giving their paintings free gestural sweeps with richer, more translucent materials. Today, petroleum products are used to create a variety of colours. There is a joy in preparing a canvas the traditional way, melting beads of rabbit-skin glue to protect the surface from the acidic qualities of paint. It all smells so great. Turpentine and linseed oil make a great cocktail.

POISON

Just last week my grand-nephew was pulled from my studio after smearing his face with cadmium red, which thankfully these days contains no cadmium. My father used pots of Flake White, which was derived from lead, to lighten his paintings. Once I was found sitting on his palette, covered from head to toe in the toxic paint and about to drink from an appetizing mug of linseed oil. Paint can be poisonous. My father liked to get a point on his brushes by pursing them between his lips. He died of stomach cancer at the age of sixty-three.

Industrial methods in the arts lead to industrial illnesses. The screen wash used in screen printing has long been banned in art schools, but not before many of the medium's key innovators in the 1960s had died of cancer and strokes.

How about this...?

MAKE A PINK-ON-PINK PAINTING

Agnes Martin made white-on-white paintings after her friend Ad Reinhardt, who had made black-on-black paintings, killed himself. She left New York City and headed to New Mexico. In the mid-twentieth century, making monochrome paintings was seen by some as the extremist action of a nihilist, but it eventually came to be understood as working with the material surface of a painting. Choosing to make a pink-on-pink painting today might seem inappropriately trivial compared with the boundary-pushing work of Martin and Reinhardt, as well as other trailblazers like Kazimir Malevich and Robert Ryman, but in doing so we are still engaging in the retinal physicality of painting. Deny even denial. Take the act of painting to the outer limits.

MAKE A SELF-DEFEATING OBJECT

These are often objects of derision. 'Chocolate Fire Guard', my teammates called me, as I stood in goal on frozen Saturdays on the football field. Deliberately making an object out of a material that does not work allows you to explore both the nature of the material and the shape of the object.

I love cast chocolate objects. When I was a child we had chocolate 'smoking kits', including pipes, cigarettes and cigars. Children these days have to make do with chocolate tool kits, which are still fun but lack the desultory allure of self-harm simulacra.

Casting objects is a way of excavating meaning. Objects can be cast in plaster, rubber, bronze, iron, concrete, jelly and resin. I avoid resin. I once taught a student who made a project of masturbating into ashtrays filled with resin. The resin captured his output forever, but later that summer he developed cancer and had to have a testicle removed. For artists, it is important to wash your hands before you go to the bathroom as well as afterwards.

SKIP DIVING

Finding materials is a useful way to engage context, as well as being cheap. For years I have scavenged skips for free surfaces on which to paint. Doors are marvellous for this. In the UK, house-proud but deluded homeowners are constantly ripping out their kitchens and building loft conversions. This means that British skips are full of the most wonderful seasoned doors. These doors are of a level of quality and workmanship no longer available to the homeowners who rip them out. Our most beautiful art and design objects, from plastic bottles to tins to cardboard boxes, end up in landfill every day. Rescue these items and make beautiful art from them.

CASTING

We can fabricate objects, we can carve objects, and we can cast objects. My mother inherited from her family a unique tradition of casting vegetables. She was taught to make casts of potatoes and other root vegetables in plaster. Her innovation was to use concrete to cast soft fruits like strawberries. She called them her 'seasonal sculptures'. My mother taught my wife, and I have taught our children. Our loft is full of brightly coloured painted concrete vegetables. We sell them at art fairs.

FABRICATION

I fabricate pseudo-votive figures of people that are important to me. Armed only with a Makita drill, I place found materials and other beachcombed bits of plastic and timber on top of each other, and then join them together with screws and glue. They become figurative totems and I paint them. This kind of visual language is magic.

JUNK

I grew up next to a rather ramshackle farm. It was full of improvised solutions and short-term fixes. Fallen-down dry-stone walls would be traversed by bedsteads. Dogs would be kept in abandoned cars. Holes in slate roofs would be filled with used plastic fertilizer bags. It was all rather unsightly in the Yorkshire Dales National Park. But we were

miles from workshops and hardware stores, and sheep farming has never been lucrative. The farmer was certainly recycling. He and his cousin did not have proper workwear. They wore suits that had become frayed and worn, tied together with hay-bale twine. I was inspired by the farm. My mother got angry with me for using spoons as tyre levers, but she grew plants in teapots.

The use of objects has an intelligence to it that evaporates when contemporary consumers throw away their IKEA purchases because they have fallen apart. The poverty of life in the Yorkshire Dales does not need to be revisited, but we should appreciate the manufacture of objects and not just delight in their function. I use radios as heads for many of the votive figures that I construct. I buy the radios from a junk shop in Ramsgate run by two men called Ivor and Thomas. The business they run is a network of recycling. All true junk shops operate in this way. The owners scour local sales and boot fairs for interesting objects. They store them until a new home can be found.

Sculptors operate in the same way. Making sculpture involves the artist in stewardship of the material world. Cornelia Parker is a good example. When I first met Parker, I was an undergraduate at Reading University and she was trading in bric-à-brac as a part-time job. Her student house was filled with pots and pans and broken ornaments. She would run stalls most weekends. Her work developed into the manipulation of these objects as art, first by casting them and suspending them from the ceilings of art galleries. Later, she asked the British army to blow up a shed full of these kinds of objects. Parker has flattened brass instruments with steamrollers and extruded the valuable metals in objects, turning rings into wires.

FUNCTION

Some artists think about the material nature of objects by deliberately underplaying their function and highlighting their metaphorical significance. Louise Bourgeois was concerned with the symbolism of the found object. In her work *Cell* (1989–93) she carved an element from almost black granite, which stands for eyes, seeds or perhaps ovaries.

'MAKE ART

DANGEROUSLY'

DO SOME CREATIVE IRONING

Ironing is about formality and lends itself to precision. Ironing can be done well or badly. To depart from the rules is to depart from an unforgiving set of principles. Make an artwork based on creative ironing. Ironing is about folding. See how close to origami you can get in ironing a shirt. How precisely can you create a variety of angles? Is it best to use a white shirt, or can you create interesting relationships and disjunctions in a patterned one? Branch out. What if you were to cut a Battenberg cake in an unexpected way, to create diamonds rather than squares?

This strange and uncanny black object is surrounded by beautiful, faded mirrors. The significance of the mirrors as contested viewpoints – onlookers at the scene – is remarkable. Here the function of the object has been subverted, and it is for us to make new use of the allusions in Bourgeois' art about childhood and voyeurism.

IMAGINATION

James Joyce, in conversation with the writer and painter Arthur Power, said: 'The important thing is not what we write, but how we write, and in my opinion the modern writer must be an adventurer above all, willing to take every risk, and be prepared to founder in his effort if need be. In other words, we must write dangerously.' So it is in working with materials. Materials engage you in an often precarious conversation in which there are no safe refuges, no comfortable answers. By holding, lifting and shaping a material, you understand something about that material, and you understand something fundamental about humanity. Our curiosity in materials and what they can do directly connects us with the cave dwellers who first forged iron tools and knapped flint arrowheads. All materials have their own life and origins, but in them we can imagine new possibilities for ourselves.

WHO AM I?

IDENTITY

At what point does a human being become interesting? Of course, all human beings are interesting. But what gives artists the right to make art that is about themselves? Art requires a degree of confidence and self-belief. This is undeniable. I have been advocating that we should take the arts more seriously in our school system because it has been proven time and again that teaching arts subjects to children develops their voices and promotes self-belief. If we teach children how to sing, dance, write and draw we create human beings who have, literally, developed their voices.

I have already suggested that your authority to speak about the issues that matter to you comes from your experience. Artists are people who have no problem with engaging in the world. To make art, even if you need to be alone when you make it, is to say to the world: **How about this...?** Making art is itself an enriching experience, which can be learned from. That is the crux of what I am saying – 'learn from making art', not 'learn how to make art'.

For some artists, telling their story is enough; others have to go on a journey to find a story. For many artists, a dialogue with materials, forms and time makes up the story.

AUTHORSHIP

I am going to explore the idea of identity through the concept of story-telling or narrative. I am Bob and Roberta Smith, two people wrapped into one. That is impossible. My real name is Patrick Brill. The point about the invention of Bob and Roberta Smith was to try and question visual art's dependency on the authorship of 'The Artist'. Visual art is perpetually tied to the truth of the artist's personal story in a way that doesn't trouble writers in quite the same sense. In literature, novels are for the most part understood to be stories invented by the author. Elements of stories may be autobiographical or based on anecdote, but in the literary world there is a licence to invent stories that does not exist to the same degree in visual art. The expectation is that the idea of truth in a novel lies *beyond* the personal story of the author. We are allowed

DEVISE AN IRREGULAR BLOB AND KEEP IT IN YOUR WALLET OR PURSE

I am not a spiritual person, but I have been intrigued by the Buddhist idea of the mantra, given by a spiritual teacher, on which to meditate. It is an immaterial keepsake. When the venerable art historian Ernst Gombrich was interviewed for the BBC Radio 4 programme *Desert Island Discs*, he was asked what book he would take with him to the island. He replied that he already took with him all the poetry he had learned as a child. He said it was important for children to learn poems, because if a catastrophe befalls you – he was, of course, talking in the context of the Holocaust – nobody can take poetry away from you.

I carry with me a favourite splat or blob. These can be taken from me, but who would steal a random blob? Inkblots are good, but these days few people use fountain pens and blotting paper. At the end of a week, make a series of random marks on a sheet of paper, then cut them up and choose a new splat to take around with you each day in your wallet or purse. You will always have your art with you. After reading this book, you will always have art with you.

TRANSFORM AN OBJECT BY FINDING A NEW FUNCTION FOR IT

What is the true nature of the objects around us? Objects originate from complex processes and are put to a multitude of uses, creating new meanings. Transform some objects. These transformations can be simple and everyday, like coffee pots filled with flowers, or utilitarian, like the screwdriver I used for many years instead of a car key. Improvised solutions are moments of ingenuity and invention – a necessary art. Transformations are also made when objects stop working. When something stops working, display it as a sculpture on a plinth or in your front window.

to travel further in our imagination than the author's own perception.

An artist's identity, on the other hand, is tethered to their work's meaning or truth, and we are also asked to pay attention to the imaginative work that they have already done. Art is about looking, as we have discussed, and the first person to do this looking is the artist. Whatever the visual artist produces is tied to his or her literal point of view and his or her experience. That is not to say that artists are solely concerned with empirical truth, like researchers in universities. Hieronymus Bosch was not actually present in 'the garden of earthly delights', and the Surrealists created extraordinary worlds of fantastical beasts and outlandish feasts.

FICTION

When I lived in New York in the 1980s, I wanted to be part of the New York Art World but had no connections. Before the digital age, one way to promote yourself and your artwork was to take photographic transparencies (slides) of your work and send these around to galleries. Some galleries opened their doors to artists, but most did not. I sent my slides out with stamped addressed envelopes. I quickly amassed a large collection of rejection letters. Some were short notes: 'Seen it before, pal!' Others were more polite, passive-aggressive rejections: 'Thank you for sending us your slides, but our programme is prepared three years in advance. If you wish, do feel free to update us with developments in your work.'

I became very interested in this aspect of the art world – its attempt to remain aloof and not be swamped in a sea of mediocre creativity. I almost sympathized with the galleries. I then invented six artists with six different bodies of work. Bob Smith was an invented artist, who used slogans and instructions as art.

Matt Groening's *The Simpsons* had just been launched. I called one of my artists 'Bart Simpson'. I have a letter rejecting Bart Simpson's abstract paintings. I felt like replying, 'Don't have a cow, man!'

As I received more letters back from galleries, I collected other stories of art world failure from fellow artists. Inevitably, the stories

reflected artists' desperation and their willingness to humiliate themselves, as well as the art world's iron-plated shield, erected to preserve its orthodoxies and to maintain deference from outsiders. One gallery seemed interested in my slides, but asked me to come back in eighteen months' time. That seemed like rather a long wait. Another gallery liked the work and invited me in for a meeting. When I visited the gallery, the young woman at the desk burst into tears when I asked to see her boss. She sobbed that he had had a heart attack and died the day before.

REALISM

They all had their excuses – death or ennui. There is no reason why private galleries, who are under pressure to sell artworks, should have to deal with a mountain of unsolicited art. Artists can be unrealistic about the capacity for a gallery to sell their offerings. I returned to London from New York. I set about recording all the stories of art world failure in a video where I told the stories as if they had all happened to me. I invented England's most... least successful artist.

I sold the video to the Tate Gallery. It is one of the most successful artworks I have made. How to escape my 'loser artist' identity became my next mission. My attempt to question the idea of identity had almost derailed my career, but through the whole endeavour I found my voice as an artist. In making the film *Humiliate*, where I told these stories, I realized that part of my artistic shtick was writing. The text art of Bob and Roberta Smith, and the use of video to compile voiced stories, are rich seams of ideas that I am still mining.

REPRESENTATION

I am obsessed with Joseph Mallord William Turner. There aren't too many artists like Turner in the art world. He wrote his own story. In Mike Leigh's biographic film, the actor Timothy Spall played the artist as if he was a grotesque. But Turner was a complex and brilliant figure. If you had met him he might have resembled Alan Sugar, Damien Hirst and Michael Caine all wrapped into one. The image of Turner as a

weird grotesque comes from accounts written by men who likely did not understand him – men who were perhaps jealous, or simply of a different class that allowed them to consider themselves more elevated, if less talented.

All artworks are about identity, but each artist must create their own narrative. If you don't tell your story, nobody will. That's the story of working-class artists, women and ethnic minorities in the art world. At the Royal Academy in London, the female perspective on art was largely disregarded for a century, and only in the last few years have black and Asian artists been represented.

If you, as a minority figure, take the necessary step of promoting your own art, you might be accused of making 'misery memoir', of navel gazing or narcissism. If you are pointing out injustices, you risk being labelled as 'divisive'. Let the begrudgers accuse you of these things. If you have a good story, tell it, film it, paint it, or even invent it. The artist Janette Parris, when she was a student on the Goldsmiths MA course, created a terrific series of paintings of her fictitious black family, satirizing the white art world's desire to fetishize the origins of black artists.

Your voice matters. It's important to write yourself into history. Don't get written out. Make your presence felt.

YOU

One of the most iconic approaches to making work about identity is that of Frida Kahlo. Kahlo painted herself alongside imagery of those she came into contact with, and what was happening around her. Peter Blake did the same, and so have many artists from Tracey Emin to Madonna.

Rembrandt's portraits chart the life of a man who knows how to look at how he looks. As a young man he painted himself as an aspirational dandy, but as he matured he became beautiful, though strange and unworldly. Rembrandt's self-portraits are perhaps the greatest of all portraits made by artists of themselves.

Talk to yourself. Imagine the events of the day as paintings. This is quite literally self-affirming. The visual equivalent of talking to yourself

MAKE A SYMMETRICAL STENCIL BASED ON THE SHAPE OF YOUR NOSE

The nose is the avant-gardist's favourite comic extremity. The absurdist Russian writer Nikolai Gogol identified the potential of the nose in his short story entitled, simply, *The Nose*. The nose in his tale escapes the face of a petty official who is 'going nowhere', and lives a life of grandeur, hobnobbing with town dignitaries.

We all have noses, and they are all comic. A fine nose is a thing of beauty, and also a laughable trumpet. I have a particularly large and beaked nose. It is also bent from a schoolboy fight and reminds me of a moment of cruelty on my part that I have paid for every time I look in the mirror.

My father had the same nose, and now my son has inherited the shape. My daughter has inherited a splendid nose linking her back to her New York ancestry through her mother. Draw your family's noses through the matriarchal and patriarchal lines. Then create a stencil and develop a painting using these shapes.

is to imagine your life as a film. Who would play you in a film? In my biopic, I would choose Angelina Jolie to play me.

To construct a film, you need to create a storyboard. If you paint important scenes in your life, you will have to encounter two important aspects of image-making: figurative painting and the power of the attribute.

ATTRIBUTES

Research Gothic paintings of the lives of saints, or Indian miniatures, and you will see how gestures play a large part in storytelling. In paintings of the life of St Catherine, the saint is depicted in various states of martyrdom: she is beaten, placed in a pit, then tied to her infamous 'Catherine wheel'. Christ is recognized as Christ not because of what he looks like, but because of the presence of a cross or a crown of thorns. St Jerome is accompanied by a book and a lion, and in rather macabre paintings St Agatha holds her breasts on a plate. The power of the attribute is undeniable, as it makes key figures unmistakable in storytelling.

If Mannerist painter Agnolo Bronzino wanted to suggest that his sitters liked a bit of fun, he would paint the god Bacchus frolicking behind them. According to his visual language, the image of a young woman holding a closed book implied chastity. If she was reading the book, however, and therefore taking in the world, then she was worldly.

VOICE

All aspects of the arts are important in developing your voice. If we don't teach children to perform, how will we hear from them later? Teach a child to sing, to write, to paint, and you are offering society a vocal participant in democracy.

Who am I to talk about identity? Well, I speak with the authority of a white male who understands and knows that people like me have acted like the colonizing grey squirrel, suffocating opportunities for fellow squirrels of other hues. We shout about ourselves and co-opt the idea of equality for ourselves. When questioned about our preferences for favouring people like ourselves, we like to claim that our choices are

not about prejudice, but rather that we are concerned about the 'greatest art' or the 'best person for the job'. These arguments are not only disingenuous, but can also be overpowered with one simple thought: art is about storytelling, and it is vital to hear everybody's story. We must be curious about a broad range of stories, answers and viewpoints, embodying different perspectives. Teach a still life class to twenty-five students, and you garner twenty-five different viewpoints. The more viewpoints, the stronger the picture of the whole, and the more authoritative and resilient the understanding of the subject. Boards of trustees of arts organizations should not consider themselves valid unless they look like the communities they serve. In London, that would mean twenty-five per cent of board members should come from an ethnic minority, and fifty per cent should be women.

SPIRIT

Alongside dealing with the hand that has been dealt to you, you have the potential and responsibility to drive curiosity and forge your own identity. There is an *esprit d'art* just as there is an *esprit de corps*, a joy in camaraderie. *Esprit d'art* is a kind of shared individualism, and an argument for free expression.

ESPRIT D'ART is Cornelia Parker crushing thirty pieces of silver and blowing up her garden shed.

ESPRIT D'ART is Ai Weiwei traveling to Szechuan Province to visit the site of a school that had collapsed in an earthquake. The school had been built from powdery concrete, cheap steel and corruption. He collected the school bags of the children that had died there, and exhibited them around the world. Ai Weiwei got beaten up and imprisoned for his trouble.

ESPRIT D'ART is Helen Chadwick pissing in the snow and then casting the void in plaster.

ESPRIT D'ART is the Brazilian artist Lucia Nogueira wearing earrings made with vials that contained explosives. If they had ignited, they would have blown her head off.

ESPRIT D'ART is J. M. W. Turner tying himself to the mast of a ship in order to paint a storm.

ESPRIT D'ART is Kara Walker building a sphinx from sugar in the defunct Domino Sugar Factory in New York City, highlighting the legacy of slavery in our sweet tooth.

ESPRIT D'ART is Yinka Shonibare kitting out Nelson's ship, HMS *Victory*, in African sails.

ESPRIT D'ART is Gustave Courbet standing at the barricades of the Bastille before making a painting of the prison courtyard.

ESPRIT D'ART is Henri Matisse slumping in an armchair to look at his beautiful combinations of greens, blues and reds.

ESPRIT D'ART is Pablo Picasso travelling to a World Peace Congress in Sheffield to declare, 'I stand for life against death. I stand for peace against war.'

ESPRIT D'ART is everything Vincent van Gogh said or did.

ESPRIT D'ART is Louise Bourgeois smashing a pot as a display of anger with her father.

ESPRIT D'ART is Charlotte Salomon writing her beautiful, poetic, illustrated diary in defiance of her destiny in the death camps of Poland.

Art is inextricably about who you are. Art is your voice.

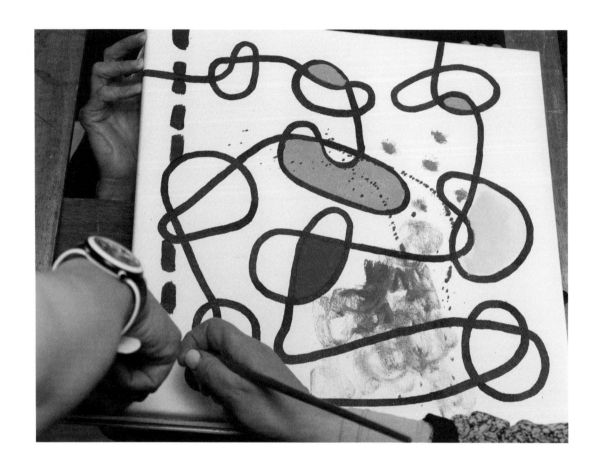

LANDSCAPE

RECONNAISSANCE

Landscape artists paint the world. One of the lesser-known facts about the origins of art schools is their links with the military. Before photography, reconnaissance of enemy terrain was conducted using a sketchbook and pencil. Among the precursors of art schools like Medway College of Art – now part of the University for the Creative Arts, in the south of England – were military academies that taught topographical drawing in the form of studying landscape. These academies had sections devoted to recording 'no man's land' in pen and ink. An army had to be able to draw in order to make notes, record fortifications, and plot the whereabouts of enemy encampments.

UNDERNEATH

My father, Frederick Brill, was a landscape painter. His father had been a sapper at Ypres. Sappers are miners who dig tunnels and fight underground. Some artistry goes on below the surface, and it has dark consequences. My grandfather dug below enemy lines following plans and maps to alter the enemy's topography – to alter the landscape from below ground. The alterations were done with explosives and caused death. My grandfather was following plans designed for him by artists. My father's concern was above ground.

OVER THE TOP

My father took me on his forays into the landscape. I was armed with a small metal box that contained not sandwiches but tablets of watercolour. I also had a pad of cartridge paper. We went on foot. We had other tools. There was a folding metal stool to perch on. My father would have a lightweight easel and a cylindrical tin filled with prized sable-hair brushes. We had jam jars full of water and a large heavy flask of tea. We were equipped with what we needed, like soldiers going into enemy territory, on our mission to record visual information.

I loved these trips, but in truth my stamina for contemplating the shifting clouds and light from a distant vantage point was exhausted

MAKE A PAINT BOX FROM A CHOCOLATE BOX

Chocolate and egg boxes make brilliant paint boxes. Put acrylic paints into the compartments where the chocolates or eggs were, and use the lid of the box as a palette. Go out and paint – paint directly and do not draw.

Go out on a blustery day to paint a tree. You will feel the wind in your hair and get a sense of what it means to *be there* while you make art. Your presence is heightened when you try to accomplish something taxing in bad weather.

Re-live Turner experiencing the storm. Imagine the difference between making an image of a storm *in* a storm and taking a photograph. If you enjoy this sort of thing, art stores will sell you all sorts of fun equipment for painting in the landscape, but all you need are the basics – smears of paint and a paint box, some brushes, and a panel to make an image on. Making art is an act. The 'act' of making art is the key thing.

How about this...?

PAINT THE MOON IN THE DARK AT NIGHT

Elsewhere in this book I will talk about
J. M. W. Turner's love of painting sunsets (see p. 123),
but in one sublime and mystical work he painted the moon.
Moonlight, A Study at Millbank is an image of stillness and
reflection, painted by the artist as a young man in 1797.
Three years later, in 1800, his mother, Mary Marshall,
was incarcerated in a mental asylum commonly known
as Bedlam. It has been written that Mary never recovered
from the death of Turner's sister at the age of four.
Turner's nocturne, now part of Tate Britain's collection,
shows light in darkness, offering the promise of hope.

much sooner than that of my father. Whole summers would pass while my dad camped out on a hillside.

We painted watercolours, which would take weeks to complete before we would embark upon oil paintings. I was happy painting for half an hour, but then I would wander off homeward, leaving him behind. My father was enthralled by what he saw. What he was doing was imitating the artistic endeavours of his heroes from the eighteenth and nineteenth centuries – Gustave Courbet, J. M. W. Turner, John Constable and Jean-François Millet. Painting was hard work. When the sun went down and the light failed, he would return, occasionally sunburnt, but more often drenched and bitten from head to toe by midges. He constantly smoked a pipe to keep the flies away. He often had stories about being chased by bulls or shouted at to 'Get off my land!' by angry farmers.

ELEMENTS

Amateurs walk, but professionals sit in the landscape. My father was a professional. He sold his paintings. There was no outward sense whatsoever that he enjoyed what he did, but I think he did enjoy himself – he liked the discovery of how the light of Wensleydale changed, and how with it the world changed. He had morning paintings and afternoon paintings. There were different paintings for different locations – looking west in the morning as the sun rose in the east, and looking down the valley to the east as the sun set in the west. He listened to the curlew's long cry in the evening, to clouds of starlings in swarms, and to blackbirds in hedges. After many years he got to know the farmers and they no longer shouted at him to get off their land. His art was a performance.

Landscape painting requires the presence of the artist, which, according to the American conceptual artist James Lee Byars, is his 'best performance'. In art of the landscape, someone is there. The landscape artist is there both for themselves (to make the art) and for us. This idea of the artist being there for us is important. Art and artists act as life's witnesses and guides, if only we are wise enough to see them. Artists can be weathervanes of human sensibility and morality. Artists like

my father, landscape painters, are literal weathervanes, burnt in the sunshine and frozen in the winter.

FIELDS

Richard Long walks and manipulates his surroundings as art. It's a poetic and literary project. Field names and valley names are plotted and recorded in his deeply humanistic art. The names of fields are human beings' vernacular conceptual art – an attempt by humans to name and claim space, and to claim the world.

The land art of Robert Smithson, Michael Heizer and Walter de Maria had other aims. If Richard Long is a semi-poetic figure, channelling the activities of writers like Bruce Chatwin, obsessed with the 'links with the land' attributed, for instance, to aboriginal peoples, then the American land artists were 'frontiers' men. We have talked a little about the notion of the 'sublime' and its importance in understanding the relationship between what the artist sees and what the artist does (see pp. 46–7). The American land artists of the 1960s and 1970s wanted to work with the material of what they saw. They wanted to work with the land itself. In de Maria's works, like *The Earth Room* (1977), rooms are filled with displaced soil. In Smithson's *Spiral Jetty* (1970), located in the Great Salt Lake in Utah, the land itself becomes art. In 1977, de Maria went further still, inviting lightning to become art as it was conducted to his own lightning field, composed of steel poles arranged in a grid, far out in the deserts of Catron County, New Mexico.

OWNERSHIP

Landscape art has its roots in the Enlightenment and in natural science, but also in ownership. Painters like Thomas Gainsborough and J. M. W. Turner were obsessed with the landscapes of French artists Claude Lorrain and Nicolas Poussin and their qualities as enchanting Arcadian visions. For the commissioners of these paintings, art was simply concerned with capturing all that they owned and surveyed. If Gainsborough romanticized the distant villages disappearing on

TRAVEL TO WHERE YOUR FAVOURITE PAINTING WAS MADE

My mother painted this painting in the 1970s. I recently travelled back to Battersea, where it was made, with the writer and filmmaker John Rogers. Remarkably, the scene had not changed at all. The concrete works were still there, though updated. The pub remained, but now as a thriving gastro pub complete with roasted beetroot salads and organic Cumberland sausages. It was moving to revisit the scene. My mother used her car as a studio because she had none of her own. I joined her on at least one of the trips when she was making this painting. I can remember walking through the deserted streets and down to the foreshore to look for driftwood while my mother worked. I have inherited from her the instinct to make art whenever and wherever one can. There never comes a perfect time – seize any opportunity to make art.

How about this...?

PAINT A TREE

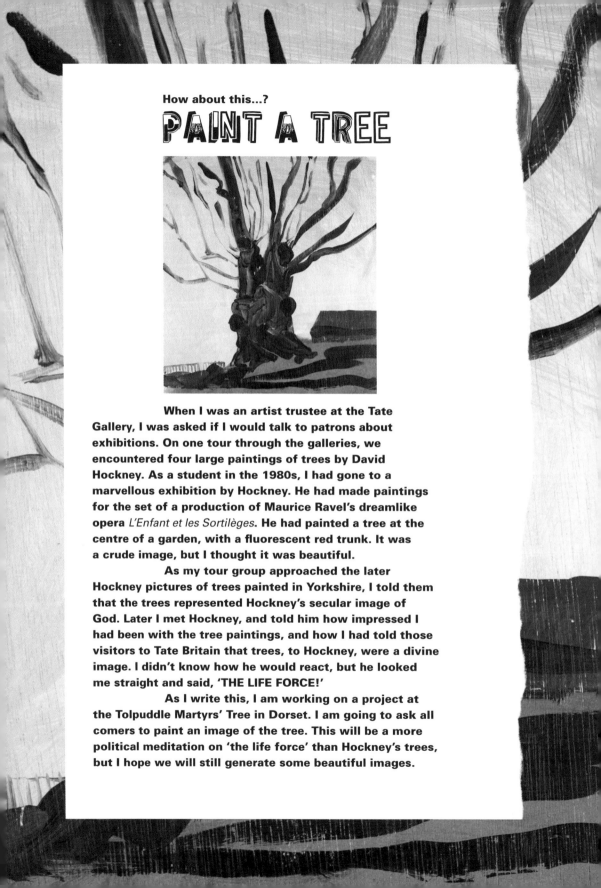

 When I was an artist trustee at the Tate Gallery, I was asked if I would talk to patrons about exhibitions. On one tour through the galleries, we encountered four large paintings of trees by David Hockney. As a student in the 1980s, I had gone to a marvellous exhibition by Hockney. He had made paintings for the set of a production of Maurice Ravel's dreamlike opera *L'Enfant et les Sortilèges*. He had painted a tree at the centre of a garden, with a fluorescent red trunk. It was a crude image, but I thought it was beautiful.

 As my tour group approached the later Hockney pictures of trees painted in Yorkshire, I told them that the trees represented Hockney's secular image of God. Later I met Hockney, and told him how impressed I had been with the tree paintings, and how I had told those visitors to Tate Britain that trees, to Hockney, were a divine image. I didn't know how he would react, but he looked me straight and said, 'THE LIFE FORCE!'

 As I write this, I am working on a project at the Tolpuddle Martyrs' Tree in Dorset. I am going to ask all comers to paint an image of the tree. This will be a more political meditation on 'the life force' than Hockney's trees, but I hope we will still generate some beautiful images.

blue horizons behind his subjects, the subjects themselves, who were paying for their portraits, were concerned with their depiction as gods. In painting them, Gainsborough cements their gaze, as they rule the roost, for eternity. The sitter owns everything in the background behind them; the demonstration of their extreme wealth is amplified in paint and canvas. The rolling downs and lakes of the landscape architect Capability Brown are similarly the managed landscapes of wealth. Those vistas have value.

INVENTION

Light in the landscape constantly changes. Landscape artists are therefore confronted with an impossible task. All landscape art is about time. While a painting portrays a moment, the painting itself has been made over time. The landscapes of Constable never existed – the clouds are agglomerations of believable sketches. It is Constable's genius that we are fooled. Constable was a magician.

Seascapes are an even greater invention. Turner painted from his lover Sophia Booth's house in Margate. Her house faced west over the Thames estuary, which Turner drew and painted as the sun set. This sunset over water is a near unique phenomenon in eastern England, and it gave Turner licence to invent.

My father had a theory about Turner: everywhere in Turner was Margate. 'That's Margate,' my father would say as he stood in front of a Turner painting of Venice. Napoleon in exile in Elba? 'You can almost see the medieval towers at Reculver!' Gazing at the burial of Turner's friend David Wilkie off the coast of Gibraltar in the painting *Peace – Burial at Sea* (c. 1842), my father would say, 'That's Margate. Turner never visited the Strait of Gibraltar.' All sunsets are Margate.

It's a fair claim when one considers Turner's seascapes. Everything is confabulated and invented from drawings. The flat sands in the foreground of many of Turner's sunsets seem like an estuary, and typical of Margate where the bay is broad and shallow. In Margate, the sea skims out as a sheet of foam at low tide, and the wind whips up the high tide into cavernous sweeps of terrifying energy.

Landscape need not be rural. One of the greatest landscape artists of our day is not a painter but a writer. Iain Sinclair's remarkable book *Hackney, That Rose-Red Empire: A Confidential Report* (2009) hacks and conjoins social stories of the East End with the urban city. Sinclair documents the crunch and collapse of the old city under the foot of the developer. The lost stories, the allotments, the societies are all celebrated and recorded as living elements in the landscape of Hackney. Sinclair is one of many writers trying to scratch at the impossible relationship between time and geography. W. G. Sebald's novels attempt this same feat in the context of Nazi-occupied Europe. In *Austerlitz* (2001), Sebald's eponymous character travels across landscapes whose peoples are anaesthetized to their own histories and topographies. A true understanding of human experience can only be gained by tapping into the landscape, and art is born out of the difficulty presented by this task.

The English landscape in the pre-industrialized era had more in common with the Hackney of Iain Sinclair than the desolation of the contemporary countryside, with its fertilizers and Range Rovers. Then it was richly populated. We see this abundance of humanity in Thomas Hardy's novels. Fields in summer were filled with workers and threshing machines. In autumn, ploughing populated the land with horses ripping up the soil. The human effort and manpower needed to farm was immense. Markets were filled with traders, and there were mines and lime kilns dotted everywhere, creating fertilizers and products needed for tanning and forging.

HOME

Turner and Constable were not trekking out of the city for some peace and quiet. Rather, they were heading towards the action. Landscape was where it was all happening. Even if modern populations are tied to their cities, landscape is at the heart of most nations' sense of themselves.

In China, strange, tall mountains emerging from lakes are traversed by the Great Wall. America has the Grand Canyon and Rocky Mountains. France has the Camargue and the Alps. Italy is arguably more renowned for its landscapes than its cities. Think of Umbria, Calabria and Tuscany. The great cities of Florence and Rome are nestled by mountains and rivers, where the links of aqueducts and railways emphasize the dense population's dependency on the industry of the countryside. The food of Italy, with its rich cheeses and sauces, reflects these close links. When visiting vegetable markets in Italian cities, one sees an abundance of produce that is fresh, free from genetic modification, unnecessary commodification and plastic packaging.

The landscape painters of the past were trying to picture the essence of the countries where they lived, and on their travels abroad brought back to us images of the world that deepen our understanding of what it means to be alive. Landscapes are where we live. We all have hinterlands that shape and form us. The art of landscape is the art of what is just beyond us. We make the landscape our own. The green patchwork of fields that we think of as 'Great Britain' have been as contrived as any artwork, but many think of it as 'home'. Perhaps human beings are so attached to this idea of home because it's hard to escape the footprint of our ancestors.

The further artists have travelled across the landscape, the more loudly they have found their voices. As with a student embarking on a gap year, whose parents hope they will learn as much about themselves as the countries to which they are travelling, when we look at landscape art, we are looking at ourselves.

CHAPTER
9

CORRECTNESS

If you set up a 'still life' with apples, pears and other fruit, as Paul Cézanne would have done, you are engaging in a sculptural exercise that is all about form. Ability in representational, non-abstract still life painting or drawing is apparent to all, and the results can be fairly straightforwardly assessed – mistakes are obvious, and improvements can always be made. Such still life involves a finite set of objectives, allowing value judgments that might otherwise be easily dismissed as mere 'opinion'. This exercise of still life painting or drawing therefore allows the student and teacher to engage in a conversation where they are able to discuss right and wrong. This is a rare thing in art teaching. This cruel but educative space is rarely considered in art school these days, but on foundation courses and in secondary education, still life is alive and well. If taken seriously, it is a poetic space for contemplation.

ALTERED STATES

After the emergence of photography, human beings became blasé for a while about the skills involved in drawing or painting from life. But seen through fresh eyes, the skills of the seventeenth-century Dutch still life artists are mind-bendingly extraordinary. For the citizens of the Lowlands, looking at paintings by the Dutch masters Willem Kalf, Pieter Claesz or Rachel Ruysch would have been like our generation gazing into a high-definition TV. The experience of looking would have been a thing of wonder.

Later generations have engaged in some mind-bending of their own. Many of the same skills apply in painting objects as in making them. Cézanne's still lifes are inventions of spatial relationships. Each painting is like a city. Each arrangement of apples and jugs and cloth has suburbs, a centre and a hinterland. It's these spatial relationships that inspired Georges Braque and Pablo Picasso. These relationships, which could be developed, distorted, compressed and extended, led Braque and Picasso to invent Cubism, which in turn inspired a hundred years of artistic endeavour. Artists exploring the formal properties of art and objects gave birth to what became known as 'abstraction'.

PAINT A SERIES OF OBJECTS AND MAKE A STILL LIFE WITH THEM

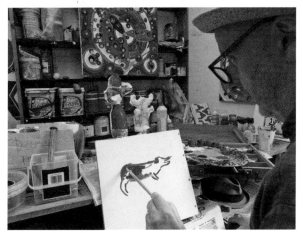

Make a painted sculpture, and then paint a still life image of it. This can be a shortcut to surrealism.

Paint objects in unlikely colours, and make an arrangement of these objects that you can draw on all sides. Think about this arrangement both as an artwork in itself and as a starting point for finding colours and forms to structure your image.

Once you have a painted image in either acrylic or oil paint, and once it has dried, experiment with making glazes to run across the surface. Glazes can be liquid or translucent colour, pushed across the surface.

MAKE A COFFIN FOR AN IMAGINARY PET

When I met the Ghanaian coffin maker Paa Joe, he had seen an online project I had made for a group who were attempting to ask people to think more creatively about funerals. They had organized an exhibition, held at the Roundhouse in London, for which they had asked artists to devise creative coffins. I decided to make two coffins from fruit boxes. I had seen a film from 1979 of the Günter Grass novel, *The Tin Drum* (1959). At the end of the film, the stepfather of the child at the centre of the story dies and is buried in a makeshift coffin. During the funeral, the man's arm falls out of the side. My exhibition was a huge success, but I did not sell the coffins. At the end of the exhibition I had to dispose of them. I put the coffins in the back of my car and drove them to the dump. As I pulled them from the car and placed them among a pile of unwanted debris, two concerned operatives in yellow vests approached me. I told them that all was OK, because this time the coffins were empty.

DEATH

Place a lot of fruit together, and you will rapidly realize that the bananas go rotten quickly when placed next to the apples. Still lifes are autumnal spaces, where everything is dying, time is running out, and life is ebbing. Fruit has been picked and is gently ripening, then rotting. The art of the still life is the entropic art of watching – in a voyeuristic manner – objects, full of life, slowly die.

The contents of still life painting are not meant for the stomach, but for the wastebin. In the sixteenth century, a fashion emerged for what became known as 'vanitas' painting. Vanitas paintings were concerned with death. Their characteristic images of skulls are part of the story for good reason. These are paintings about the transience of life. Apples rot, we die. A mawkish preoccupation with death underlies the still life in general. Still lifes are essentially depictions of death. Life is not still. Life is, well, full of life... It is joyful and exuberant. Seventeenth-century Dutch still lifes are among the most virtuosic examples of the form. These were demonstrations of the artist's ability. To paint the surface of a lemon, the sparkle on a glass of wine, requires extreme skill. Still life painting captures minute moments of life's journey into oblivion.

COFFINS

Making a film for the BBC, I worked with the Ghanaian coffin maker Paa Joe, who makes coffins in the image of bottles, fruits and fish. Indeed, most of the coffins Paa Joe builds could form the repertoire of the classic still life painter's art. His practice is part of a Ghanaian tradition of burial in a figurative coffin, which might be the image of the trade in which the person was occupied.

Paa Joe and I buried a sculpture I had made of Picasso in the body of a lion. According to the tradition, only chiefs get buried in lions, so it seemed appropriate that the Grand Chief of Art should be encased in one, too. I wanted to say something in the film about Picasso's dependency on African art. As discussed earlier (see p. 55), the invention of Cubism and Abstraction owed much to African masks which were being traded in Europe at the turn of the nineteenth century.

The repetitive abstract patterns of African art migrated from African objects to French paintings. I wanted to return Picasso to Africa in order to poetically call his bluff. We buried Picasso in a graveyard in Accra, to which we processed with the lion. The film is oddly moving. Considering that no one had died, I was surprised to find myself, and the film crew, almost in tears. We had made Picasso the artist into a still life. As we buried the lion containing him, I thought about the value of objects and art. I asked Paa Joe how he felt that his life's work as a coffin maker had been buried in the ground, in a rather unloved graveyard on the outskirts of town. He said it was sad.

Paa Joe has many works in museums around the world, and he is celebrated for his art and his craft. As an artist, he stands in a uniquely powerful place. His is an art of objects between life and death. He is an artistic ferryman on the River Styx. Some artists become more than what they seem to be. Paa Joe, the coffin maker from Accra, is one of these people. He is a Picasso figure. Paa Joe's coffins represent what Picasso's *Guernica* represents – both life and death. Still life. As I nailed together my figure of Picasso, Paa Joe's son turned to me and said, 'Mr Picasso won't like this.'

JOY

My mother taught me to draw by showing me how to sketch a Christmas pudding. She said, 'Draw the custard first, then underneath draw in the pudding. Draw what you like in your pudding – cherries, nuts, and chunks of ginger. Now place the pudding on a plate.' She said, 'Draw in your friends. Let's invite everyone to the party. Art is an invitation. Put the holly on the top of the pudding. Now everyone is sitting around the pudding. Let's draw flames. Let's set that Christmas pudding alight!'

QUIET

Still life, for both my artist parents, was for wet days. No possibility of going outside? Then paint inside. Still and quiet, both my parents worked in their respective spaces in our house. As a child, my elder sister Victoria would join in with their painting, but I would play or

How about this...?

MAKE A NUT AND BOLT CALZONE

Continue the theme of using kitchen materials (see p. 92) in this next project. Substitute pastry for clay or non-firing clay to create pies and other foodstuffs. Marbles, nuts, bolts and other unwanted detritus from the bottom of an old toolbox work well as fillings.

How about this...?
MAKE A PLASTER TRIFLE

 In this recipe, gravel can become chocolate, marbles can be cherries, and plaster can be cream. Pieces of chalk can be used as finger sponges. This exercise is a kind of joyful substitution of art for reality. Have fun.

 Why not organize a group show that works like a potluck dinner? Using these simple principles, invite others to make sculptural banquets. Everyone will bring something unique to the party/exhibition.

 Here's a tip: don't experiment with drinks in this way – it can be fatal. Flash cleaning fluid looks like lemonade, but can be deadly if ingested.

read. The house was shrouded in concentration. No TV, no radio, no music; rooms filled with thinking, concentration and silence, the only sound the rain pattering on the windowsill. No shadows, everything lit like a Giorgio Morandi. Still lifes can be quite austere. The still life painter Morandi created a painting every day of his life, asking, 'What can you do?' As with the conceptual artist On Kawara, who painted the date of each day he lived, Morandi's art charts time. Each painting, made in a day, compresses the time of a day into one vision. There are no shadows because, as time passes, shadows die.

MEMORY

Our house was filled with objects to paint – interesting things. Staffordshire figures, decorated plates, tin toys, jugs and fabrics. Charles and Ray Eames made photographic cards of interesting objects to contemplate – lots of stuff. The people who make programmes about 'de-cluttering' would be horrified by these scenes, but psychologists, who think that something about ourselves resides in what is around us, would understand. I have done many projects with Alzheimer's patients; I have begun to understand that to clear away their objects is to throw away their souls. Still lifes become banks of pretexts to remember; collections of memory objects.

In 2009, I lost my eyesight due to a period of 'optic neuritis' caused by anaemia. I went blind. I also suffered from terrible headaches and began to feel unconnected to the world around me. This was not helped by the fact that I couldn't see anything. Slowly my eyesight recovered, and slowly my connection with the world felt more profound. Throughout this whole episode, the objects that were around me and the tools of my trade – paints, brushes, palette knives and my own palette seemed to remind me of who I was. I suppose we are back to the idea of feedback loops (see pp. 13 and 25), and of who we are being tied to what we have around us.

INVENT A NEW HEAD FOR AN ANIMAL

I once made an exhibition in Turin where I asked all comers to invent a new head for a cat. I displayed the upright body of around thirty plaster cats and supplied clay and wooden modelling tools. The local art school was invited to the event. I was impressed by the manipulative skills of the Italian students. They were virtuosic with the clay. They all made the most imaginative and artful additions to the cat body. The project was a 3D take on the surrealist 'Exquisite Corpses' – collections of words and images assembled by multiple collaborators (see p. 26).

All the recipes in this chapter have been art games. It is important to take play and playfulness seriously. Playing with substituting materials, one for another, is fundamental to seeing the possibilities in methods and forms, and also links the adult mind straight back to the metaphorical mind of the child. Children see no problem in saying that one thing is another.

POP

I recently inherited a painting by my mother of her early married life in 1946. It is a picture of a utility table, cheaply built but well made, with tins and jars filled with ingredients. It is a celebration of all that my parents could get together in a time of austerity.

In later still lifes by my parents, idiosyncratic, almost Pop Art objects appear. My father was known as Fred Brill. Fred the Flour Grader, a small plastic figure in a bowler hat, who was used to advertise Home Pride flour products, appears in my father's work. Very 1970s, not very 1790s – still life can be about humour, as well as death.

My father had a perverse tick of arranging objects so that it was virtually impossible for the viewer to understand what the objects were that he was painting. I have a painting by my father of an ancient toaster, of a type that has not been available for fifty years. It is placed at the front of the composition, obscuring an orange Roberts Radio from the 1980s; the tuning knobs are just visible. It is a mad painting that nobody would buy. I don't think my parents ever sold any of those still life paintings. They were exercises for them to amuse themselves and improve their skills – philosophical puzzles involving time and space.

Later my mother, Deirdre Borlase, went on to make large watercolours of still lifes that sold like the hot cakes they sometimes depicted. Her touch, and the feeling expressed in her work, were as charming as her lesson to me about drawing the Christmas pudding. Her paintings are curious and upbeat, featuring objects she loved. For her, art was life – still life.

EXPRESSION

AMAZING DEEDS

This book has been about how curiosity is a responsibility. The most impressive artists I have known feel the responsibility of human beings to be all that they can be.

One of my favourite artists is the British Nigerian Yinka Shonibare. Yinka does not let a minute of the day go by unused. He pushes each idea that comes to him to deliver original, powerful statements about the world that are enriching to the viewer. I first met Yinka when he created *Nelson's Ship in a Bottle* (2010) for the Fourth Plinth in London's Trafalgar Square. It remains a triumphant image of post-colonial criticism. Replacing Admiral Nelson's sails with vibrantly patterned fabrics traditionally originating in Indonesia then manufactured in Holland for a West African market created an image of a different, alternative world. The ship is, at once, an angry image and a healing image.

My other great heroine of art was the Brazilian sculptor Lucia Nogueira. I made a painting that declared *I believe in Lucia Nogueira* (1997) in our house in Ramsgate. Lucia's studio was like a laboratory. She was an 'art scientist', making ink drawings that exploded and sculptures that flew. She enclosed spaces with long red sausages made from stuffed felt, which got trapped under heavy metal objects. Her art was about psychological states – our fears and our delights.

People are inspiring. Artists are inspiring in that they live by their deeds, not their words. My art, which involves painting words, is an attempt to turn the word into a deed. That's why I am writing this book. Writing is a deed. Artists are exposed to judgment, and if we admire them, we can worship them. I don't think artists are gods, but I do think art is worth believing in. The great thing is: if they are alive, we can even meet the artists we worship, and go to their exhibitions.

TOOLS

My father once said to me, 'Just to be interested in things is wonderful, but to have some talent and ability to craft things – words, music or materials – is a gift. Don't waste your talents.' I'm not sure that talking about the notion of talent is very useful; for me, the key task *is* 'just to

How about this...?

IMAGINE A BETTER WORLD

 Imagine a situation in which human beings were more interested in the world in *all* **its aspects than in the borders and barriers of nations.**

 The arena of imagination is not confined to artists or 'creatives'. Arguably, the greatest political imagination of the twentieth century belonged to George Orwell, the author of *Animal Farm* **(1945) and** *Nineteen Eighty-Four* **(1949). Orwell was many things, but central to his being was his deep and free-thinking imagination.**

 The imagination is not only concerned with dreaming up the future; it also reads current events. People with imagination are either accused of having 'visions' or being 'fearmongers'. But it is important to nurture the human imagination in all its facets. The arts in school help to realize pupils' imaginations.

TUNE A GUITAR TO THE HUM OF YOUR FRIDGE

Tune an electric guitar to the hum of your fridge. This is a great thing to do. The resultant harmonic hum, reverberating from guitar to fridge and vice versa, is amazing.

Some of the greatest visual artists of twentieth-century America were also musicians; and many of the ideas of Minimalism are more acutely expressed in music than in visual art. La Monte Young, Terry Riley, Steve Reich and Philip Glass have created music that is also conceptual art, and continues to inspire artists today. Contemporary artists like Haroon Mirza mix music, culture, science and found objects into fantastic installations.

be interested in things'. Get curious. Take the world apart like a child, and put it back together again like an artist.

In the introduction I described curiosity as if it were rather like an algorithm that you, as a reader, can activate by making your own art (see p. 14). You can help to change the world by generously inventing new worlds. By talking about art in terms of algorithms, I have not been saying that art can be made to a formula, but rather that curiosity is a tool with which we process the world, and this starts with looking. Curiosity points our attention to things, asks us to understand them, and provides us with the tools and materials to make things.

Art is about looking and making judgments. Art is about shining light, and ultimately it is about rights and free speech. It is true that art pre-dates democracy, and that dictators, barons and kings have used art for their own purposes. But art can also aid democracy. You, sitting on the sofa, reading this book... you are in a position to access this power of art.

ACCENTS

The way human society is arranged, most human beings rarely get to express themselves. We all have voices and we all have accents, but most of us never get to discover our visual voices, let alone our particular visual accents. The closest we come to this discovery is to choose our clothes, decorate where we live, or do a bit of gardening. Society has reduced our visual soul to a set of meaningless consumer choices. Women get to wear some bright colours, but most men wear navy blue, grey or black.

We are, for the most part, mortgaged to careers, in which we have been taught to be useful, not inventive. Our sense of our value is rarely attributed to our inventiveness, and never to our imaginations. But society does admire those who exhibit these qualities. Why are most people so inhibited when our heroes can appear so exuberant and free to be themselves?

CREATIVITY

Contemporary society is run rather like the one in Aldous Huxley's sci-fi novel *Brave New World* (1932), where there are two types of warring beings – 'creative' and 'uncreative'. In real life, employers and governments, aided by parts of the education system, tell us that our purpose is, above all else, to work, and that our education is all about getting a job. Of course, we do need to work, but if you are able to work on the things and issues that really matter to you, that is a powerful and enriching approach to life. Education is valuable because it ignites the spirit of curiosity, not because it will give us a certificate.

Books like this one are published with a view to explaining the habits of 'creatives', but this is a nonsensical category, for we are all essentially the same in relation to creativity, with similar potential and motivations. There are not two kinds of human being – nobody is 'uncreative'. All human beings can make things, and can make things happen.

PRECARITY

We have a lot to lose, however, if we decide to earn a living in the arts. To fail as an artist is to fail financially, but also spiritually and morally. Failure as an artist can seem catastrophic. Art is so much the flesh of who an artist is that failure can feel like failure as a human being. Artists might conclude that it is better to deny their creativity completely, and to subjugate themselves to unwanted careers rather than to try to realize a life as an artist. *Allow yourself to fail!* The trick is to be strong enough to get back on your feet. To be creative in the twenty-first century is to take risks. The aim of this book is to ask you to be more adventurous. Grab a pencil and express yourself. By the time you have a pencil in your hand, you are armed with an exciting tool that can pretty much do anything.

Pencils can inspire, and can make people cry. Paintbrushes can tell your story, record events and shine a light. Sheets of paper can point out injustice, describe the world and excavate the past. Video works can explore our nature, highlight points of view and shade in grey areas. Art can devise new worlds simply in its haptic qualities, and in the joy of mark-making.

How about this...?

MAKE SOMETHING BEAUTIFUL

I have talked in this book about the impossibility of making art, and how art is essentially a declaration by artists that something is art, and how art often resides between materials and forms. I have chosen synaesthesia as a metaphor for the idea that one thing can be something else.

We have looked at how curiosity can be applied to the world like an algorithm, unrelentingly turning over stones. Now make something beautiful. What do you consider visually beautiful? Not *who* (that is easy), but *what*?

PAINT A CLOUD

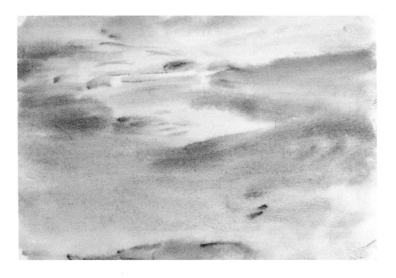

As I have discussed, clouds are impossible to paint (see p. 47). It is only possible to make an *image* of something, not the thing itself, and this is particularly apparent in the case of clouds, which are ever-changing and difficult to grasp. Whatever shape a cloud is, it is still beautiful. I have never heard anyone say, 'What an ugly group of clouds.' In this exercise, you may not use photographs. That's cheating. Look at a cloud. Paint it, and remember it.

MANIFESTATIONS

Does expression mean throwing paint around like Jackson Pollock, or is it about Billie Holiday's purity of voice? Is purity of expression to be found in the considered jazz constructions of Leonard Bernstein, as in his masterful 1961 score for *West Side Story*, or in the free jazz leaping of the Art Ensemble of Chicago? Is free expression the minute brush-strokes of Andrew Wyeth or Jimi Hendrix's guitar solos?

Since Sigmund Freud we have thought a lot about 'expression' particularly as something psychological. But artists have always expressed themselves. By painting Adam on the Sistine Chapel ceiling, Michelangelo was expressing himself. Adam is one of the most expressive sexualized artistic manifestations ever imagined.

SCRAWLS

Expression relates both to what is said and how it is said. German Expressionism of the early twentieth century was expressive both in terms of the dark politics of the period and of mark-making. Paintings from the movement depict streetlights and smoky clubs. This kind of expressionism is about the fear of what lurks in dark corners. As we discovered, the figure hiding in the dark corners of anti-war painter George Grosz's works was Hitler.

The American painter Cy Twombly expressed a kind of poetic understanding in his gestural scribbles. He was expressing the power of language, but also its limitations, highlighting the difference between thoughts and words. The texts that Twombly wrote are mostly indecipherable. We can't tell what they say, yet the visual effort is Herculean. The gesture itself is pure expression.

Jean-Michel Basquiat's painted slogans came from overheard language. Basquiat crossed out the words he most wanted people to read. Visually, the crossing out itself is more legible than the untouched words. It is an art of perversity and teasing. Basquiat was a game player, like a James Joyce of hip-hop.

Expressionism can feel like a bombastic song in a bad musical. Raw expression has become frowned upon in the art world. There is a kind

of conceptual etiquette, born out of twentieth-century modernism, that is afraid of expressive gestures. American artist George Condo makes a virtue of this trope. He turns the great moments of art into cartoonish scrawls, lampooning artists' vanity.

Andy Warhol is perhaps the most notable expressive artist America has produced. His marks are like quotations of expressive sweeps of reds, blues and greens, reproducible again and again. They can be ordered in whatever colour the buyer might prefer. This kind of expression-quotation seems appropriately manufactured for twentieth-century mass-market America. 'Blue Warhol, please – I'm feeling down.' 'Certainly, sir. That will be $200,000, please.'

SHOCK

In the 1980s, American artist Andres Serrano constructed an art of provocation by placing the figure of Christ in a tank of urine. In the 1990s, a lot of British artists exploited the shock value of images. The artist group BANK made a project of satirizing the manners of the art world. Their exhibitions 'Zombie Golf', 'The Charge of the Light Brigade' and 'Cocaine Orgasm', held in disused industrial spaces in London's East End, were reflections on art's more vainglorious aspects.

In 'Zombie Golf', Peter Doig, who is quite an expressive painter, was persuaded to show his paintings on a fabricated golf course filled with golf balls placed by hastily made 'zombie artists'. The curators of 'Charge of the Light Brigade' recreated the British cavalry's fruitless death charge in the Crimean War in papier-mâché, upside down on the gallery ceiling. My band, The Ken Ardley Playboys, lampooned the death throes of The Beatles by playing on the roof of the building (not very well; we tried to learn the songs, but they were too complicated). In 'Cocaine Orgasm', artworks were buried under a snow of white powder.

These shows ironized the capacity for artists to self-indulgently splurge their 'gestalt' gestures while expecting audiences to be interested in them, but the exhibitions were themselves a grand 'anti-gesture'. The 'anti-gesture' is its own kind of expression, and it has its roots in punk. Punk was inspired by the Situationists in Paris, and the legacy of the

DEVISE A WORKSHOP

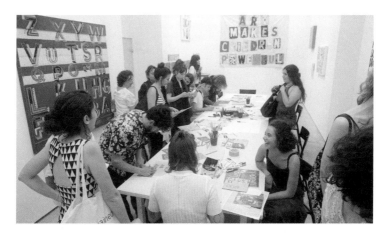

If you had to teach an art workshop, what would you teach? Now write your workshop. The process of devising a workshop will force you to ask yourself why you would want to teach what you do. What qualities does your art have that are valuable to pass on? In education, we would call these the 'aims' of the class.

Herbert Read, the great post-war educator, thought that everyone should be taught through art, but he also thought that art could not be taught. One could teach techniques and illuminate the history of art, but the individual act of art – its motivations and passions – could not be passed along. The idea sounds contradictory, but I think I agree with Read.

If art can be taught, it is by example. This is why workshopping is important. The enthusiasm and the interests of individuals are critical. Being an artist can be like being a great singer – no one can sing just like you, but you can inspire others to sing. Singers teach singing, but they can't find your voice for you. This is also true in art. Your voice needs you.

How about this...?

INVENT NEW WORDS

CRESIP

DRAWP

Invent words which are also sounds, and which expand language.

1968 student revolts. Situationism in turn has its roots, among other things, in Dada, renowned for its satirical, 'anti-art' character.

EMBARRASSMENT

Purely expressive art can be embarrassing. It's why we have the *Literary Review*'s Bad Sex in Fiction Award for writers. Writing about sex is almost impossible because writing about sex, like writing about how it might feel to jump into a frozen lake, highlights failings in human language more than it illuminates sex or extreme cold. If you don't understand the limits of language, then you can quite quickly produce kitsch. Imagine if Jackson Pollock's 1952 painting was not titled *Blue Poles* (also known as 'Number 11') but instead *Orgasm 1, 2 and 3*. This might have led to 'expressionist embarrassment'.

FEAR

Nonetheless you need to dare to be expressive, and to feel you have something to say. *Have an opinion.* To say something demands confidence and also hard work. But the more you practise an activity, the more skilled you become. The African American artist Kara Walker is perhaps the most fearless image-maker of her age. Initially working with cut-paper figures, then moving on to video works, she has explored the horrors of black history in a way that makes one feel ashamed of the human race. She draws a line, cutting her images with a razor-sharp sensibility. Her expression is both personal and collective. Her art is a scream as loud as that of Edvard Munch.

STYLE

Your signature is an expressive gesture. Children spend long afternoons devising elaborate signatures. Queen Elizabeth I had a signature with lots of joyous, expressive curlicues. I tell my students that if they want to sign their art, they should write their name in a way that can be read. David Hockney got that right. A name on a print needs to be legible, especially if no one knows who you are. If, as an artist, you develop a 'signature style' or a brand, like Damien Hirst's dots or Tracey Emin's

monoprint scratches, then a footballer's scrawl is perhaps permissible.

My mother used to sign her paintings with only her surname to hide her gender. She disguised her identity because she believed the selectors at the Royal Academy's Summer Exhibition were prejudiced against female artists. When she signed her work simply as 'Borlase', or entered the competition as 'D. Borlase', she found she was selected more often.

'Make your mark', say artists like me. Your style, your expression, is not necessarily a curated effort. Your style is how you walk, your voice and your dexterity with a pencil. It's how you dress and how you think. Your self-expressive nature should be all that you are. Most men don't wear blue or black all the time. Human beings need to show off in discreet acts of exhibitionism. Expression is a joy. What you are interested in can become your art. Your only barrier to succeeding is the limit of your capacity for curiosity. *Go further, make it bigger.* Make it sexy! How crazy can you make it?

EMANCIPATION

The question of expression is fundamental to thinking not just about art, but about 'the arts'. As an artist I am concerned about freedom of speech, because I think that it is vitally important for human beings. Historically, free speech has been fundamental to the struggle for human emancipation.

Sometimes it might seem as though the language of art can get in the way of its expressive capabilities. But while the artist might handle language ineptly, we should remember that ultimately it is the manipulation of materials that facilitates the emancipation of the artist. Materials are amplifiers. By paying attention to this, we – as audiences – can allow art to emancipate us.

DECIDE WHEN TO STOP

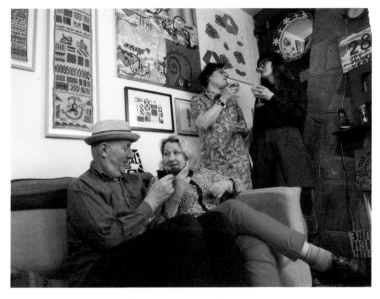

Now create an exhibition in your front room of all the things you have made. Link them with string at points where you can see a relationship. Invite your friends, and run workshops teaching what you have learned.

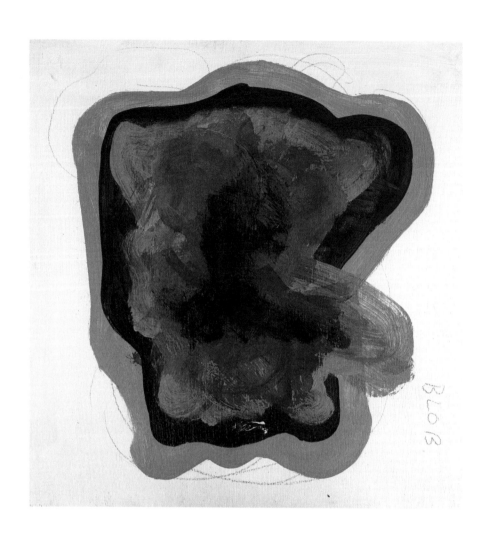

'EVERYONE IS

AN ARTIST'

Chapter 10

EFFORT

The nineteenth-century art critic John Ruskin held that nations could be judged by their deeds, their words and their art. Ruskin thought artistic production was the most telling indicator of a country's character. This is because the artist has the opportunity to capitalize on all aspects of life, making his or her efforts a comprehensive statement about a life lived. I think that all people are artists. I am not alone in this. When the German artist Joseph Beuys declared that 'everyone is an artist', he was echoing the German political philosopher Hannah Arendt, who looked at the aftermath of the Nazi era and concluded that democracy was best protected by a society that was 'performative, participatory and associative'. We have a responsibility not to consume without thinking of our actions, but instead to make things, and to make things better. *Get out there and make your own damn art.* In making art, you will not only help yourself but you will help us all.

EPILOGUE

YOU CANNOT TEACH ART
But all the best artists are teachers

Some time in 1933 in Westgate, on the outskirts of the seaside town of Margate, on the bleak northern coast of Kent, my mother was day-dreaming and intermittently making a drawing in her schoolbook. She was meant to be learning religious studies. The schoolroom looked out over the sea, and she was drawing people walking and gazing at the ocean. Her teacher snatched the drawing book from her desk and threw it on the fire. The Bible bored my mother; this was her punishment for free thinking.

'You cannot teach art.' Art is dependent on individual voices and experiences, and ability in art is in some sense a gift or a talent. But in that schoolroom in Westgate, the unforgiving teacher unwittingly created an artist. My mother, Deirdre Borlase, realized at the age of eight that drawing gave her a special power. A power that was all hers. A power that the teacher was frightened of and did not understand. Experience creates artists. Sometimes these experiences are positive, like being shown how to do something complicated by someone knowledgeable, and occasionally they are negative, like my mother's experience with her teacher.

DON'T MAKE ART LIKE ME
But do make art

I teach in art schools. For me, it's not a full-time job. I am lucky enough to make most of my income making artworks, but I also feel a need to teach. In this book, I have tried to explore what I teach. Most artists working in arts education today would agree with me when I say, 'Don't make art that looks like mine, but do make art.' For most of art history this has not been the received wisdom. The first significant formal art school in the UK was the Royal Academy. It was set up by highly skilled artists like Thomas Gainsborough and Sir Joshua Reynolds to teach the making of pictures and sculptures and to impart to students,

initially all male, the practical skills and attitudes needed to make the art of the day.

Before the establishment of the Royal Academy, to learn art would have meant working for an artist, rather like an apprentice. You would have made your employer's art for him, and perhaps only fully 'graduated' when you escaped his employ. This practice dates back at least as far as the Renaissance. One can imagine craftsmen and women around the world passing on to their charges the tricks and skills of their trade. This kind of approach can still be found in architects' offices. A celebrity architect might devise a 'scheme' that is then enacted by a whole office of aspiring young architects in the celebrity's name, but this ploy has largely faded from the habits of the art school.

Until the 1960s, art students would be inducted into the working methods of their tutors. Ancient (mostly male) figurative painters would indoctrinate students into painting naked young (mostly female) art students. Abstract sculptors (the more macho, bearded students) would gather together to be radical and smash their plinths, while more conceptually minded tutors would be setting fire to things or damaging film stock. Now we live in more polyphonic times. So just what is taught in art schools, and how can YOU learn to be an artist?

All artists are teachers. Art is fundamentally about showing people the world, but the manner of the teaching is never straightforward. Art is perhaps the one subject where the teacher should not know the answers to the questions he or she poses. The great artists who have also been teachers pose questions, but it is the student who needs to work out what the question is and how to ask it in their work. We are all teachers. We are all students.

When I was a student, I bought a copy of Paul Klee's masterful teaching manual *The Thinking Eye*, composed of notes, essays and lectures from 1922 to 1924. It cost me £50. I thought of reading the book as necessary research for my undergraduate dissertation. However, understanding the book in the normal way – working from front to back in the accumulation of knowledge – very quickly became irrelevant. The book is a series of explanations of different visual phenomena,

esoterically illustrated in Klee's scratchy hand. Each idea is an artwork, just as much as each page is an artwork. There are sections on rhythm and perspective, but also sections that look like musical notation or explanations of geological sedimentary formations. The book is its own formation of a series of wonderful ideas, and now looks idiosyncratic in a way that Klee would never have acknowledged.

Klee saw *The Thinking Eye* as a tool, much like his shorter *Pedagogical Sketchbook* (1925). It was made to give to artists and students to aid in their comprehension of the world at large. We are all involved in a continuous curiosity feedback loop. Perhaps Klee's greatest teaching was not in his pedagogical explanations, but in his life and work. All artists, whether they like it or not, teach by example.

THE THREE BS
Bourgeois, Beuys and Baldessari

LOUISE BOURGEOIS taught in seminars, but also – by example – revealed a new lexicography of frustration and anger. Right up until her nineties, Bourgeois invited artists to her studio in Brooklyn to discuss their works. There are wonderful videos of her being mean and irascible with her victims, but also being bright and nurturing. She is like the mother spider that is perhaps her most powerful image. Bourgeois taught by being curious about her younger fellow-artists. Her greatest lessons were her *salons*; her best teaching involved her own interest in new ideas. Bourgeois had the wit to extend to the students who visited her attention, interest and a sense that what they were doing was important – something she had never experienced herself as a student. This is an interactive thing. Art happens between human beings. The conversation always runs two ways, even if it takes place between a person and an object. Through art we can fall in love across generations. I love Louise Bourgeois. When I see her work, I can see my love is unrequited. I can see that she is sticking two fingers up at my male gaze. She is dead, but she still lives. Louise Bourgeois will live as long as there are people to look at what she made.

When I lived in New York in the 1980s, I was enrolled as an associate student at the Cooper Union art school. But I went there infrequently, feeling that my time in New York was best spent exploring the city, trying to engage with artists, and making paintings. One morning I followed up a contact I had with the director of the library at the Museum of Modern Art (MoMA), Clive Phillpot. I expected that everything at MoMA would have a kind of modernist order to it. Clive showed me into his office. Clive Phillpot's office was amazing. It was a chaotic library of magazines, journals and huge art books, with no discernible cataloguing or order whatsoever. Clive is a fanatic about the 1960s Fluxus movement. Fluxus had bemused the public; it was as if confusion was the aim. The artists who comprised the movement included George Maciunas, Nam June Paik, Yoko Ono, Gordon Matta-Clark, Gustav Metzger and Joseph Beuys. They were one of the first international, revolutionary global art brands.

JOSEPH BEUYS taught at the Düsseldorf Art Academy in the early 1960s. His students included a lot of rather macho neo-expressionist painters like Jörg Immendorff and Anselm Kiefer. What did he teach them? Beuys is famous for accepting every student who applied to work in his studio. Düsseldorf Art Academy soon sacked him. The German system of art education to this day has the air of a Renaissance 'studio'. Students work alongside their tutors, and tutors get to pick their students. Beuys believed that 'everyone was an artist'. If everyone is an artist, why have a selection procedure? It is possible to see Beuys's gestures as an artist as part of a process of recuperation of German history.

Beuys had been in the Luftwaffe, and had flown Stuka attack fighter planes. He had been awarded the Iron Cross twice. After the war he had a psychological breakdown. Art was involved in his coming to terms with the war and his role in it, and in his rebranding as a shaman of peace and the environment. Beuys wrote his curriculum vitae, and only afterwards went about enacting it. Using chalk on a blackboard, Beuys taught poetic and almost psychedelic lectures about how the power of the sun was akin to the energy of a cabbage. He taught a kind of artistic moral responsibility that had not been available in the

Germany he grew up in. Anselm Kiefer's obsession with Wagner and German history is evidence of the force of Beuys's teaching. Did Beuys fully grow to escape his youth? I am not sure.

I once attended a lecture by Gustav Metzger, who had been an important part of the Fluxus movement. He came to Britain as part of the *Kindertransport* – a rescue effort for German children prior to the Second World War. Metzger's family was annihilated in the death camps in Poland. His work was about destruction. He was also a teacher, and taught at Ealing School of Art in the 1960s. After attending a Metzger lecture, Pete Townshend of the band The Who started smashing up his guitars on stage. I asked Metzger his thoughts about Joseph Beuys, but he refused to answer – he would not talk about Beuys. But Beuys's lesson to us is huge. It is about self-invention and redemption. Beuys was hugely influential in pointing to the responsibility of everyone both to and for society.

JOHN BALDESSARI taught at the California Institute of the Arts for nearly twenty years. 'Cal Arts', as it is known, is famous for producing savvy, intellectually versed artists, able to traverse the contemporary terrains of artistic and philosophical practice. Baldessari would probably be the first to describe this description as bullshit. I went to Goldsmiths College in the 1990s. Goldsmiths was kind of the English answer to Cal Arts, and had by that time developed a formidable reputation for pseudo-intellectual art discourse. But in truth, all its tutors – people like Jon Thompson, Jean Fisher and the artist Michael Craig-Martin – wanted students to read a little, and to realize that there was a world out there beyond art.

Baldessari poses a threat to conventional art school practice because he both took it seriously and outrageously satirized it. The artist Paul Thek had done a similar thing at Cooper Union in the late 1970s. Thek provided a series of questions to students, which were both formal and personal. Some of those questions were psychoanalytical. He was interested in how the individual experience of the student and their psychological state might be apparent in their artworks. Thek was exhibiting meat in a vitrine with flies as early as 1963. Baldessari

turned Thek's questions into propositions and actions, rather like Wittgenstein's treatises. Baldessari had students writing lines like: 'I will not make bad art.'

A slogan I painted early on in my career was 'Make your own damn art. Don't expect me to do it for you!' I came up with this at a printing workshop run by the Migros Museum at the Liste Art Fair in Basel. Migros had invited a lot of young artists to work with a letterpress company at the fair, to give away free prints and subvert the market. No matter how many prints we all made, there seemed to be an ever-increasing demand. In exasperation I began to insult the art collector crowd via my slogans. 'Make your own damn art' was born out of tiredness with the collectors' desire for the 'art object', and the corruption of the experience of 'looking' by the supremacy of simply 'owning'.

The function of art and artists is to inspire. The worst outcome of this book would be if it inspired armies of people brandishing homemade political slogans. My mother recently passed away. Before she died, I asked her, 'What is the secret to a good life?' She said, 'Get a good pencil: a 2B or a 3B, not an HB – they are for architects.'

That's what you should do. Get a nice soft pencil! And with that pencil, do as Hannah Arendt would do: perform, participate and associate.

ABOUT THE AUTHOR

Bob and Roberta Smith, a.k.a. Patrick Brill, is a British contemporary artist, activist, writer, broadcaster, musician, art education advocate and keynote speaker. He is a Royal Academician, and in 2017 was awarded an OBE for services to Art. Bob is a patron of the Big Draw and the National Society for Education in Art and Design. He sat on the Tate Modern Council and was recently a trustee of Tate. He is also a Trustee of Art UK and a contributor to the *Guardian*. He has extensive experience of teaching and is Associate Professor at the Sir John Cass School of Art, Architecture and Design at London Metropolitan University. He has curated numerous public art projects, including the 2013 Art Party to promote contemporary art and advocacy. His works have been exhibited internationally, and are in collections in Europe and the United States.

ACKNOWLEDGMENTS

I would like to dedicate this book to my two children, Etta and Fergal. The book deals for the most part in why everyone should consider themselves artists so they can fully emancipate themselves and their children. This, of course, is a feedback loop, and so Etta and Fergal deserve credit for showing their dad 'the way'.

Acknowledgments, too, to my inspirational wife, the artist Jessica Voorsanger, who did invaluable work on numerous early drafts of the text; and to my father-in-law Neil Voorsanger, to whom I read the text several times in the winter of 2019.

Thanks also to Keith Sargent at Imprint, without whom I would never have designed the 'Inconsistent' font which has been used throughout this publication.

Finally, thanks to Roger Thorp, Amber Husain and all at Thames & Hudson who worked so hard to make this book look so wonderful, not forgetting Fraser Muggeridge and his design team.

FURTHER LISTENING

I listen to the radio – BBC radio and Resonance FM – when I'm in my studio. I get lost in painting and listening. For many years I've had a live radio show on Resonance FM, which we broadcast on Tuesday nights at 9pm GMT. I thought it might be fun to list some of the records I've been listening to and broadcasting while I've been writing this book. I believe there is a close relationship between music and visuality. Many of the recordings below I find inspirational, and there are also some obscure spoken-word records, of which I have a large collection.

- The original soundtrack from the film *Black Orpheus*, music score by Antônio Carlos Jobim and Luiz Bonfá, Polygram
- *Cinéma Vérité*, The Ramsgate Hovercraft, Galleon Records
- *Mechanical Keyboard Sounds*, Trunk Records
- *Artists Ruin It*, The Apathy Band, Campus Records
- *Sounds of the Countryside: Threshing and Cultivating*, Steam Power, Abbey
- *The Third Decade*, Art Ensemble of Chicago, ECM
- *Songs of Protest / People Get Ready*, from the Atlantic & Warner Jazz Vaults
- *Lionel at Malibu*, Lionel Hampton, Gala Records
- *Return – A Triumph of Reason*, Morton Subotnick, New Albion Records
- *Sounds of the Countryside*, Wildlife Series No. 5, BBC Records
- *Sound Stories: TT Highlights*, commentary by Murray Walker
- *Missin You*, Silver Apples, Enraptured Records
- *Love Story*, Tony Bennett, CBS
- The Lloyd McNeill Quartet, Soul Jazz Records
- *L'Enfant et les Sortilèges*, Ravel, L'Orchestre de la Suisse Romande, conducted by Ernest Ansermet
- *Big Bill Broonzy à Paris*, Disques Vogue
- *Arnold Schoenberg Conducts Pierrot Lunaire, with Erika Stiedry-Wagner*, CBS
- *Otis Redding – Live in London and Paris*, Stax
- *Sun Ra – Monorails and Satellites*, Evidence Music
- *Back to Black*, Amy Winehouse, Universal

What are you listening to?

PICTURE CREDITS

All photography for this book is by John Rogers.

Page 4 'Space Towers', oil on canvas, 40 × 30 cm, 2019 (detail); p. 8 'I want everyone to go to art school', signwriters paint on board, 30 × 30 cm, 2018; p. 11 'Teaching is beautiful', signwriters paint on board, 30 × 30 cm, 2018; p. 12 'All schools should be art schools', signwriters paint on board, 30 × 30 cm, 2018; p. 15 'How about this?', signwriters paint on board, 30 × 30 cm, 2018; p. 18 'Make your own damn art', signwriters paint on board, 30 × 30 cm, 2015; p. 20 'Cogitation', signwriters paint on board, 30 × 30 cm, 2018 (detail); p. 23 'Loop painting after Fergal', signwriters paint on board, 30 × 30 cm, 2018; p. 24 (top left) 'Clooney', signwriters paint on board, 30 × 30 cm, 2018; p. 24 (top centre) 'Pasta', signwriters paint on board, 30 × 30 cm, 2018; p. 24 (top right) 'One Shot', signwriters paint on board, 30 × 30 cm, 2018; p. 24 (bottom left) 'LMS tank engine', watercolour by the artist age 7, 15 × 20 cm; p. 24 (bottom right) 'Ribblehead Viaduct with Fingers of God', by Frederick Brill, oil on canvas, 104 × 130 cm, 1976; p. 27 (left) 'Don't join the Apathy Band', oil on canvas, 40 × 40 cm, 2019; p. 27 (right) The Apathy Band, featuring Jessica Voorsanger, Jo Moss and Alison Harper; p. 28 'David Nott and Eddie Mair interview', signwriters paint on wooden panels, 480 × 360 cm, photographed at the Royal Academy, London, 2014; p. 31 'Humiliate the painting', oil on canvas, 60 × 70 cm, 2005–2020; p. 32 'The Alter Destiny', signwriters paint on board, 30 × 30 cm, 2018; p. 37 (top) 'Blue Differentials', oil on canvas, 50 × 50 cm, 2019; p. 37 (bottom) 'Monorails and Satellites', signwriters paint on board, 30 × 30 cm, 2018; p. 38 Inside the LCCA; p. 40 'Two fingers of gin to one of Dubonnet', oil on canvas, 70 × 70 cm, 2019 (detail); p. 44 Heidi Lapaine and Rocky consider which painting to take home; p. 47 'Swiss Cloud', oil paint on board, 30 × 30 cm, 2018; p. 48 'Art makes children powerful', signwriters paint on board, 30 × 30 cm, 2018; p. 54 'Festival of Britain Fireworks, Battersea', by Frederick Brill, oil on canvas, 76 × 51 cm, 1951; p. 58 (left) 'Valentine card', signwriters paint on board, 30 × 20 cm, 2018 (detail); p. 58 (right) '28 years of joy', signwriters paint on board, 30 × 30 cm, 2018; p. 60 'Van Gogh', by Fergal Voorsanger

Brill (the artist's son), gouache on cereal box, 33 × 24 cm, 2012; p. 66 'Deirdre Borlase, painted from memory', oil paint on board, 30 × 30 cm, 2018; p. 70 'The democratic painting', by Alison Harper, Jo Moss and Jessica Voorsanger, oil on canvas, 50 × 50 cm, 2019; p. 72 'The Nest', signwriters paint on found timber, installation, curated by Nicolas Bourriaud, La Panacée, Montpellier, 2019; p. 81 'Free Nazanin Zaghari Radcliffe' [Ratcliffe], signwriters paint, 30 × 30 cm, 2019; p. 83 'Carperby', signwriters paint on board, 30 × 30 cm, 2018; p. 84 'Wandsworth Comprehensive', signwriters paint on board, 30 × 30 cm, 2018 (detail); p. 86 'The Galaxy Way', oil on canvas, 50 × 90 cm, 2019; p. 88 'Concrete Cocktail', 2019; p. 95 'Pink on pink painting', signwriters paint on board, 30 × 30 cm, 2018; p. 96 Making and floating a concrete boat between Ramsgate and Folkestone, 2019; p. 100 'Creative Ironing', shirt, frame, 1992; p. 102 'A variety of noses', signwriters paint on board, 30 × 30 cm, 2018; p. 114 'The democratic painting', 2019 (see p. 70); p. 118 'I can't turn you loose', oil on canvas, 50 × 50 cm, 2019; p. 121 Bob with 'The Ship Pub' by Deirdre Borlase, outside the concrete works the painting depicts; p. 122 'The Tolpuddle Martyr tree', oil paint on board, 30 × 30 cm, 2018; p. 126 'The blue pig', oil paint on board, 30 × 30 cm, 2019; p. 130 Bob with Paa Joe during the making of 'Collaboration Culture', 2012; p. 136 Bob showing his cat Carperby his three-eyed cat sculpture; p. 138 'Concrete vegetable', cast concrete, 1994; p. 141 'George Orwell', oil paint on board, 30 × 30 cm, 2019; p. 145 'I am a beautiful object', plastic milk bottle, 30 × 20 cm, 2019; p. 146 'Clouds over Pen Hill, Wensleydale', by Frederick Brill, watercolour, 18 × 24 cm, 1975; p. 149 Bob and Roberta Workshop, La Panacée MoCo, Montpellier, 2019; p. 150 'Cresip Drawp', signwriters paint on board, 30 × 30 cm, 2018; p. 154 'Create your own Blob', signwriters paint on board, 30 × 30 cm, 2019.

FRONT COVER: 'You Are an Artist', oil on board, 30 x 50 cm.
Courtesy of the artist and Von Bartha Gallery
BACK COVER: photograph by John Rogers

First published in the United Kingdom in 2020 by
Thames & Hudson Ltd, 181A High Holborn, London WC1V 7QX

First published in the United States of America in 2020 by
Thames & Hudson Inc., 500 Fifth Avenue, New York, New York 10110

Design: Fraser Muggeridge

British Library Cataloguing-in-Publication Data
A catalogue record for this book is available from the British Library

Library of Congress Control Number 2020932705

ISBN 978-0-500-23993-3

Printed and bound in Latvia by Livonia Print